**A Sexy, Steamy,
Downright Sleazy
Handbook to the City**

Printed in Canada

10 9 8 7 6 5 4 3 2 1

First Printing: November 2002 Library of Congress Cataloging-in-Publication Data

Horny? San Francisco: A Sexy, Steamy, and Downright Sleazy Handbook to the City

Edited by Cara Bruce and Charlie Amter

144 p., 5 x 7 in. • ISBN 1-893329-64-X

Cover, design, and illustrations by Ingrid Olson, Tülbox Creative Group

Visit our web site at www.ReallyGreatBooks.com

To order Horny? or for information on using them as corporate gifts, e-mail us at Sales@ReallyGreatBooks.com. or write to:

Really Great Books • P.O. Box 86121 • Los Angeles, CA 90086

Please see p. 114 for additional credits.

Horny?
SAN FRANCISCO

A Sexy, Steamy, Downright Sleazy Handbook to the City

Edited by
Cara Bruce & Charlie Amter

Los Angeles

Find updates & enhanced listings
for *Horny? San Francisco*
on the web exclusively at

eros.com

Contents

Please Read . viii

Key to the Book . ix

Contributors . x

Acknowledgements . xi

Introduction . xiii

The Big Tease: Performance/Strip . **2**
 Lingerie Modeling . 4
 Topless Bars . 6
 Fully Nude Strip Clubs . 11

Conspicuous Cumsumption: Shopping **24**
 Sex Toys and Novelties . 26
 Porn Shops: Mags, Books, & Videos . 30
 Arcades/Theaters . 35
 Lingerie for the Lovelies . 39
 Street Wear for the Slutty . 42

Sexy Sites . **48**
 Perverted Publishers . 50
 Reference . 53
 Shopping the SF Web . 55
 Escorts . 58
 Fetish Online . 63

Take Your Clothes Off and Have Fun: In the Buff **68**
 Nude Beaches . 70
 Spa/Massage: Rub Me the Right Way . 78

Make It Hurt So Good: The Fetish Scene **82**
 Shopping in Fetish San Francisco . 84
 Clubs/Nightlife . 94
 Dungeons . 99

Free Clinics . 105

Alphabetical Index . 107

About the Contributors . 111

About the Editors . 115

Please Read

- The only sure thing in life is change. We've tried to be as up-to-date as possible, but places change owners, hours, and services as often as they open up a new location or go out of business. Just call ahead if there's any question.

- Every place in *Horny?* is recommended for something. Each reviewer has tried to be honest about his/her experience of the place, and sometimes a jab or two makes its way into the mix. Remember that any reviews and/or endorsements of an establishment are the opinions of the individual editors and should not be taken as the final word. You can decide for yourself if you (dis)agree.

- Most major credit cards are accepted at the establishments herein, so charge it up. Places that are cash only have been noted as such to the best of our knowledge. When in doubt, bring some cash.

- We shouldn't even have to tell you this, but here it goes. Drink responsibly. Don't drive after you've been drinking alcohol. If a designated driver is hard to come by and you don't live spittin' distance from your favorite bar, call a cab to take you home. Split the cost with some friends and it's not even that expensive. Once you call for a taxi, wait for it. Drivers are working on their own time and stiffing a cabbie's just plain rude!

 Here's a handy list of taxi companies in the area.

 Black and White Checker Cab: (415) 468-9090

 CityWide Taxi Dispatch: (415) 920-0700

 De Soto Cab: (415) 970-1300

 National Cab Co.: (415) 648-4444

 Pacifica Cab: (650) 359-2290

 South San Francisco Yellow Cab.: (650) 992-1222

 Veteran's Taxicab Co.: (415) 552-1300

 Yellow Cab: (415) 626-2345

- And finally, should you get lucky thanks to this book, please, please, please practice safe sex! See our guide to free clinics on p. 105.

Key to the Book

For your viewing pleasure

You can be sure that a *Horny?* stamp of identification means these spots do whatever it is we say they do. This key should help you figure it all out.

 Strip Club!
Fully nude, topless, or bikini, off with those clothes . . .

 Porn Galore!
Magazines, books, and videos—smut sold with pride . . .

 Adult Toys!
Sexy toys and novelties = fun for big girls and boys . . .

 Lingerie!
Lace and leather, classy or trashy . . .

 Sexy Street Wear!
Not quite nighties, but definitely naughty . . .

 Outdoor Fun!
Find your natural side while eliminating pesky tan lines . . .

 Spa and Massage!
Clean and dirty at the same time . . .

 Escort!
When you need a little company . . .

 SM/BD/Fetish!
If you like it rough and tumble . . .

 Curious?
Gay, but straight-friendly, come see how the other side lives . . .

 Alcohol Served!
So you know it's 21-and-over . . .

 Open Late!
It's late (past midnight), you're horny, fill in the rest . . .

Contributors

Amanda X

Rebecca Anderson

Chevara Angeles

Rachel Blado

Jack Boulware

Janelle Brown

Dancer X

Dara Lynne Dahl

Diamond Dave

Dick Deluxe

Mike Ferro

Jon Alain Guzik

Gary Hanauer

Jan Holder

Alan Home

Dan Hullman

Jessica Hundley

Dan Kapelovitz

Nick LeBon

Carol Leigh

Kelly Lewis

Anne N. Marino

Margot Merrill

Midori

Lisa Montanarelli

Mistress Morgana

Michelle Parsons

Dave Patrick

Anthony Petkovich

Genevieve Robertson

Steve Robles

Thomas S. Roche

Marcy Sheiner

Kathy Sisson

David Steinberg

Dave Williams

Acknowledgements

Cara thanks...

All of my friends and writers who helped provide rock star-style reviews. I'd also like to thank my Mom and Dad (always) and sister Alli. Dave Newman, Lisa Montanarelli, Missy Axelrod, Terry Zwigoff, Blag Dahlia, Steve Robles, Anne Marino, Cleis Press, Patrick Hughes, Mistress Morgana, Fetish Diva Midori, Marcy Sheiner, Susie Bright, Carol and Robert, and all of the wonderful sex-activists, writers, and workers who have made San Francisco what it is. And Charlie—thanks for the good times, what can I say, it was a lot of fun!

Charlie thanks...

Jessica and Jon for your massively horny enthusiasm and for setting the bar sky high, Dara, Dave, Anthony and all at the *Spectator*, Margot for coming through at the last minute (you always do luv!), Mr. Dick Deluxe, Cara for your constant companionship and sense of humor through it all, Dan Kapelovitz, Gus Mastrapa, Jack Boulware, Brian Gross, Suzi Suzuki, Jen Summers, Janelle Brown, Bryna Bank, David Steinberg and everyone who decided to contribute! You all make this city a better place to live.

Charlie and Cara thank...

First and foremost our extremely talented group of contributors! All of you get big kisses from Cara and naughty things whispered in your ear from Charlie. Possibly the world's best interns Lindsay Blumenfeld, Molly Drexler, Anjali Kumuran, and Jessica Weng; Kristin Petersen for support; Janelle Herrick for getting the word out; Ingrid Olson for making it look good; and Kerry Candaele for making it right. Mari for the wonderful opportunity (and the tasty French Dip!), Susan Jonaitis for her consummate professionalism, Deb for the support up North, Brian Gross for the PR savvy, Dave Newman, again, for everything, and, of course, Mom and Dad.

Introduction

San Francisco has always been a boom and bust kind of town. From its auspicious gold rush beginnings as a mecca for the '49ers to the fabled dot-com bust, the city's fate has always been inexorably intertwined with extreme highs and devastating lows. Throughout the years there has been one constant—sex! Arguably America's most sexually adventurous, permissive, and promiscuous town, San Francisco knows how to get it on—and then some. It's the kind of town in touch with its inner freak, a town where mayor Willie Brown attends the opening of the Hustler club and proclaims it "good for the city." From the storied days of Barbary Coast bordellos to the free love revolution of the 1960s, our lovely city by the bay has continually reinvented itself as the progressive American city for the sexually liberated.

The modern incarnation of San Francisco was virtually built on the premise of acceptance. Outcasts of all kinds come to San Francisco to find both themselves and those of like mind. Where else could a sex worker run for office? Where else can a municipal employee get the city to pay for a sex change operation? Where else does a huge leather festival take over a whole neighborhood—to everyone's delight? The diversity of the city can be seen in any neighborhood, on any Muni ride, or in any strip club.

San Francisco seems like a sexual utopia to some, yet countless visitors, seduced by the Golden Gate Bridge and Northern California's rolling hills, are shocked or disgusted by the openness of San Francisco's sex scene. But if they look at the folks behind the city's steamy scene, they discover that the people involved are not sleazy at all. A city of spiritual seekers and dreamers, many San Franciscans see sex work as a sacred act with a lineage that dates back centuries. Of course, there are the hustlers too; people who simply look at sex work as a way to make a fast buck. But San Francisco's sex scene is by and large a vital and deeply rooted part of the city—happening right out in the open for the entire world to see.

While cities like New York and Las Vegas legislate their cities back to the puritan era with draconian laws against strip clubs, San Francisco's lawmakers keep their hands off the city's sex industry. They know that letting San Franciscans decide for themselves when it comes to something as personal as sex is what San Francisco is all about. Despite the loss of the porn industry to Southern California's San Fernando Valley with its cheap rents and sunny weather, San Francisco leads the country in the rapidly developing fetish arena, the evolving Internet community, and free STD testing/counseling services.

While we have attempted to cover as much of the city's colorful sexual past and present, we have unquestionably missed something. We omitted most of the city's famed gay scene, as Really Great Books' *Gay & Horny? San Francisco* has that scene covered (or should we say uncovered?). We also consciously left out much of the East Bay, Marin County, and the Peninsula—there's so much sex in the city itself, that for the sake of readability, we had to narrow our focus.

One of the most beautiful, romantic cities in the world, San Francisco pulses with the primal sexual energy. It's in the air, snaking down the back alleys of Polk Street, dancing its way through the Mission, crashing up on the rocks under the Golden Gate Bridge. We've tried to include everything in this book, but like San Francisco itself, the sex industry is elusive—often shrouded in mystery and fog. Take this book as your basic guide. But dig deeper, dig harder, and most of all, have a good time digging for sexual gold in the city by the bay! You are bound to find a nugget or two with *Horny? San Francisco*'s help.

Love, kisses, and some serious groping,

XOXO

Charlie & Cara

Get Horny!

Contents

4 Lingerie Modeling

5 Vavavavoom: The Not-So-Lost Art of Burlesque,
 by Jessica Hundley

6 Topless Bars

6 Diva Central: Tranny Culture Lives on it the Tenderloin!,
 by David Steinberg

9 Strip Club Legends: Carol Doda's Blinking Boobs,
 by Cara Bruce

10 Spin It, Sinner: San Francisco Strip DJ,
 by Diamond Dave

11 Fully Nude Strip Clubs

12 Rules of the Lap Dance: Dos & Don'ts from a Private Dancer,
 by Dancer X

15 Peep Show Show-Offs: Exhibitionists Turn the Tables on Strippers,
 by Dan Kapelovitz

16 Pave Paradise & Put Up a Parking Lot: A Former Dancer Recalls
 a Legendary Strip Club, by Amanda X

18 Strippers Need Love Too: Where San Francisco's Dancers Play
 After Work, by Charlie Amter

20 The South Bay Swirl,
 by Dick Deluxe

THE BIG TEASE
Performance | Strip

The city of San Francisco is a mere 49 square miles, concentrated in pockets of vertical urban sprawl. Contained within this small urban paradise are strippers! Lots of them—largely because San Francisco is a dancer's paradise. Despite the city's petite size, there is a diversity of clubs, so dancers can choose to work in a variety of environments. Whether she wants to work at a unionized club shaking it safely behind glass or she's after the big money that comes from full-contact lap dances, a dancer can find her niche in San Francisco.

No other city prides itself on its strip clubs more than San Francisco. The city's laissez-faire policy towards strip clubs results in some of the hottest dancers, sexiest clubs, and most "hands-on" lap dances in the country. San Francisco Mayor Willie Brown attended the opening of the new Hustler Club in North Beach. What other big-city mayor in America could get away with that without some kind of puritanical scandal?

So, take a deep breath, get those dollar bills ready to stuff down some G-strings, and let *Horny?* be your guide to the best that San Francisco has to offer!

Nob Hill Mini Lingerie Theater

Mini-Me, you complete me!

629 Taylor St. (between Bush St. and Geary St.), San Francisco;
(415) 771-6645. Open Mon–Sat: noon–3 a.m., Sun: noon–9 p.m.

This place is one of a kind and the Union Square location can't be beat.
It looks like a brothel, it feels like a brothel—yet a brothel it is not. The
front room is blood-red and has big mirrors and badly drawn paintings
of naked women on the walls. Each night, in these lavish surroundings,
two to four girls stand in a row and wait to be chosen, kind of like in…a
brothel. The customer rents a private room for $40 and tips begin at $40.
Described as an "interactive modeling show," the girls will do lingerie
modeling (if they remembered to bring some), partially nude modeling,
fully nude modeling, lap dancing, and fetish shows. Like most other San
Francisco strip clubs, for the right price, you can get whatever you want.

—Kelly Lewis

Barbary Coast Adult Theatre

Sketchy, trashy, and definitely not classy.

1260 Mission St. (between Eighth St. and Ninth St.), San Francisco;
(415) 626-9625. Open Mon–Sat: noon–3 a.m., Sun: noon–9 p.m.

Far, far away from where the infamous Barbary Coast was located, this
SOMA institution has its fans and detractors. Forty bucks gets you in the
door; what happens after that is entirely up to the girl working. Although
lingerie modeling does happen here, you can bet that if the tip is right, a
lot more will too. Most of the girls are average looking and hardly any of
them actually wear lingerie. For those who like quiet, one-on-one atten-
tion, the Barbary Coast is your bag. If you like the rules a bit more defined,
this club may leave you feeling a bit confused, depraved, or worse.

—CA

"I **never** miss a chance to have sex or
appear on **television**."

— GORE VIDAL

Vavavavoom
The Not-So-Lost Art of Burlesque

If you like the line of a lady's leg and the curve of a voluptuous back-side, but don't want the accompanying sleaze which permeates most strip club establishments, the lost art of burlesque may be for you. Since the 1800s, ladies the world over have been lifting up their petticoats and showing off their bloomers with a mixture of coyness, seduction, and a healthy sense of humor. Cancan girls at the Moulin Rouge teased the crowds with high kicks and energetic acrobatics, English damsels showed stocking on the London stage, and right here in America, vaudeville bloomed, showcasing lovely ladies and raunchy comedians. There was Weimar-era Berlin with its smoky cabarets; the Minsky extravaganza, one of America's first burlesque reviews; Ziegfeld's girls bringing bawdiness to Broadway; and the bosomy burlesque strippers of the 1940s and '50s.

The burlesque tease slowly metamorphosed into the bump and grind sleaze of today's professional dancers, who specialize in pole maneuvers, hip thrusts and ass shaking, and who rarely err on the side of subtlety. There are, however, a few SF-based acts which have made a name for themselves reviving the old-school style.

Burlesque is not about showing, it's about suggesting, about the thrill of the unknown, about glorifying the female form (all shapes and sizes) rather than exploiting it. Burlesque relies on the refined art of the tease, and it's the sly self-possession of the dancer which will keep you coming back for more. You may not see straight-up T&A at the city's burlesque performances, but you will see beautiful, talented ladies proudly flaunting their sexuality with wit, dash, and whole lot of pizzazz.

The **Cantankerous Lollies** and the **Devil-Ettes** are two of the city's most prominent troupes, and all offer cabaret-style stage shows which showcase beautiful ladies in a setting born of verve and imagination. Their acts can range from '20s bathing-beauty bounce to '30s Berlin sin to the sequined-pasty shake of '50s showgirls, all depending on the whims of the dancers themselves. Taking on a wide variety of personas, these revamped burlesque acts are not only sexy, but funny, playful, and remarkably innocent as well.

—Jessica Hundley

Diva Central
Tranny Culture Lives On in the Tenderloin!

If you're in the mood for some gender bending, head to **Diva's Nightclub and Bar**, formerly known as the Mother Lode. The transgendered habitués at Diva's range from tentative crossdressers making their outfitted debut to gorgeous, voluptuous transsexual women.

During the day, Diva's is a quietly elegant, transgender-friendly neighborhood bar and gathering place. But it heats up dramatically at night with an unapologetic sexual vibe. A huge bowl of free condoms emphasizes the fact that Diva's is one place where sex is not going to get swept under the rug, thank you very much.

Everyone is welcome here, and most of the non-transgendered people at Diva's are local men of assorted backgrounds and sexual orientations, but there are also women, couples, and tourists embracing all San Francisco has to offer.

If you know the difference between looking and gawking, you'll find Diva's a friendly, big hearted place where people are quick to tell open-minded souls the stories of their lives. And these are life stories that won't leave you wishing you'd never asked in the first place.

—David Steinberg

Diva's Nightclub and Bar: 1081 Post St. (between Polk St. and Larkin St.), San Francisco; (415) 474-3482.

Boys Toys

Would you like A1 Steak Sauce with your lap dance sir?

412 Broadway St. (at Montgomery St.), San Francisco; (415) 391-2800. Open Daily: 6 p.m.–2 a.m.

One of the worst named clubs in town (God only knows how much business they lose to those mistaking it for a gay club), Boys Toys has nonetheless made quite a splash since it opened in 1999. Located in the heart of North Beach, the flashy club caters to yuppie gluttons of all appetites. Not only can you get a lap dance at this swanky bi-level strip joint, but you can also get a New York Steak at the four-star Boardroom

Restaurant on site. Try the Vampy Veal Milanese ($36) if you're really hungry for something young and tender, especially after watching thirty-something girls try and play Lolita. Although Boys Toys is very couple friendly and has (mostly) beautiful dancers, it may not be the best place to get a lap dance since privacy can be an issue. Still, Boys Toys remains one of the most unique clubs in town, and a great place for the adventurous tourist with money to burn.

—CA

The Gold Club

The Fort Knox of San Francisco blondes.

650 Howard St. (between New Montgomery St. and Third St.), San Francisco; (415) 536-0300; www.goldclubsf.com. Open Mon–Fri: 11:30 a.m.–3 a.m., Sat/Sun: 6 p.m.–2 a.m.

For the classiest, most beautiful selection of girls in San Francisco, run, don't walk to the Gold Club. Located on busy Third Street near the W Hotel, the Gold Club caters to all types, from high-end executives to low-life students from the nearby Academy of Art College. On a busy Friday night, as many as 50 dancers stroll the club's plush two levels looking for fun. There is a main stage and two smaller platforms where you can view a sampling of the girls working that particular night. The ladies here tend to be LA-style (blonde and busty), but nearly all are prettier, classier, and more articulate than girls at comparable SF clubs. The couple-friendly Gold Club serves lunch and dinner and has a full bar and smoking lounge (a rarity in smokeless San Francisco). There is no cover charge before 7 p.m., and you can obtain a "free pass" (actually 50% off) from their web site. Don't let the fact that the Gold Club is not fully nude keep you from stopping by—the lap dances here can get very sexy.

—CA

"I think people should be free to engage in any sexual practices they choose; they should draw the line at goats though."– E L T O N J O H N

<div style="text-align: right">Performance | Strip</div>

Larry Flynt's Hustler Club

There is more to a strip club than a name...

1031 Kearny St (at Broadway), San Francisco; (415) 434-1301; www.hustlerclubsf.com. Open Sun–Wed: 11:30 a.m.–2 a.m., Thurs–Sat: 11:30 a.m.–6 a.m.

Damn skippy, this club certainly doesn't live up to its Larry Flynt moniker. But hey, if you're doing a "I don't really go to strip clubs, but it'll be for fun just this once" kind of adventure and are in the market for a big name place, then by all means, please check out the Hustler Club. The small basement club (formerly the Millennium) has bad purple and faux titanium-looking walls, one stage of strippers in pasties who could use a dance lesson or two, an overpriced champagne room, and a back room with sofas for one-on-one VIP action. All in all I found it less of a turn-on than the men's room at the Dayton, Ohio airport. One great thing I can say about the place is the framed portrait of Larry Flynt in all his solid gold wheelchair beatific-ness. The club is free before 7 p.m., so see if you can snag the photo off the wall and fit it in your pocket.

—Jon Alain Guzik

Hungry i

Lenny Bruce was here.

546 Broadway (at Columbus Ave.), San Francisco; (415) 362-7763. Open Daily: 7 p.m.–2 p.m.

A landmark of San Francisco, the Hungry i started out as a comedy club (the lower case "i" stood for intellectual) and it's where Jonathan Winters, Mort Sahl, and Lenny Bruce got their start. Now, there's only comedy if a dancer falls on her ass (it happens!). Newly renovated, the Hungry i now resembles every other club on the North Beach strip. This one, however, serves alcohol and it actually had an interior decorator at one point—the walls are adorned with gold leaf paintings that look straight out of a tacky art show. There are little booths by the front door for lap dances and the back champagne room is nicer than most other clubs in the 'hood. There are also private rooms and plenty of girls who will keep you company in one of them if the price is right. And in keeping with the Hungry i tradition, you may still be smiling at the end of the night.

—CB

Strip Club Legends
Carol Doda's Blinking Boobs

When Carol Doda was working as a cocktail waitress at the Condor, no one dreamed she would change San Francisco strip club history. But in 1964, when she donned a topless bathing suit designed by the legendary Rudi Gernreich, she turned the North Beach strip club scene on its head. Every strip club in North Beach soon went topless, creating traffic jams on Broadway. For years her pioneering breasts were commemorated outside the Condor in the form of a monumental neon woman with flashing red nipples.

The same year Doda broke the topless barrier, she began enlarging her size 34 breasts. Twenty weeks and $2,000 later, she proudly bared her size 44 boobs in her striptease act, which involved Doda cavorting suggestively atop a white grand piano that was lowered from the ceiling. In 1965, she insured her silicone-inflated tits with Lloyds of London for $1.5 million. This set the standard for the sex industry; insuring sexual attributes is now common.

Doda retired from the Condor in 1986, after her piano had earned a story all its own. In 1983, a dancer and bouncer decided to perform an act of their own on top of the piano. The hydraulic switch was flipped and the piano began to rise. The couple was soon pinned to the ceiling, with the bouncer's crushed body padding the dancer from certain death. She lived, but only after being pressed to the body as it rigor mortised; they were not found until the morning.

Today Doda owns Carol Doda's Champagne & Lace Lingerie Boutique (see page 39). The infamous sign that celebrated her was auctioned off in the 1990s.

—Cara Bruce

Condor Sports Bar: *300 Columbus Ave. (at Broadway), San Francisco; (415) 781-8222. Now just a bar—but with a really good jukebox!*

"The only **unnatural** sex act is one which you cannot **perform.**"
— A L F R E D K I N S E Y

Spin It, Sinner!
San Francisco Strip Club DJ

It's Saturday night in San Francisco and I've got five bachelor parties in the house. Fifty-six girls are on my rotation and I'm running three stages, working the lights, and programming the music. It's hectic but I'm in my element. I'm entertaining two major league baseball players in my booth when the waitress comes in with another round of drinks, and I know its time to take the crowd to another level.

I've been called the bad boy of Broadway and the Rolls Royce of voice—every showgirl's choice. The DJ is an important element in strip clubs, but the show isn't about me. It's about creating the ultimate fantasy. Playing music is only a small part of what I do. I'm responsible for the vibe in the house. The energy I produce is contagious and is vital to the club's success.

—Diamond Dave

Diamond Dave's top five requests from dancers at San Francisco clubs:
1. *Digital Underground: "Freaks of the Industry"*
2. *Sneaker Pimps: "Spin Spin Sugar"*
3. *Prince: "Darling Nikki"*
4. *Madonna: "Justify My Love"*
5. *CJ Boland: "Sugar Daddy"*

You can catch DJ "Diamond" Dave five nights a week at either the
Gold Club (see p.7) or Boys Toys (see p.6).

"There are a number of mechanical devices that increase sexual arousal, particularly in women. Chief amongst these is the Mercedes-Benz 380L convertible."

— PJ O'ROURKE

Centerfolds

I was shakin' in my shoes when she flashed those baby blues!

391 Broadway (at Montgomery St.), San Francisco; (415) 834-0662. Open Daily: noon–2 a.m.

Centerfolds is part of the Déjà Vu chain of strip clubs—and it shows. Like any chain, it's a good, dependable choice with few surprises. Most of the strippers are above average in looks, and there are usually a couple of standouts every night. They offer semi-private rooms for lap dances, two stages, and free—that's right kids, free—sodas. There's a more expensive VIP room upstairs, but it's located on a main corridor and men are constantly opening the door to see what's going on. The rooms here are nice though, and some of them have actual beds for that horizontal lap dance you've always dreamed of. If you want a decent night out to see some gorgeous girls do very bad things at a reasonable price, you can't go wrong with Centerfolds.

—Alan Home

Crazy Horse

Ride this horse before it's gone!

980 Market St. (at Sixth St.), San Francisco; (415) 771-6259; www.crazyhorse-sf.com. Open Mon–Sat: noon–3 a.m., Sun: 5 p.m.–2 a.m.

The world famous Crazy Horse is one of the few strip clubs in town not owned by mega chain Déjà Vu. Consequently, it still retains a gritty individualistic spirit that translates into an enjoyable time for men and couples alike. The central detail of the club is the fantastic, well-lit stage, which they put to good use with big time XXX stars up from LA and nightly old school-style strip shows. At a time when the art of the strip tease seems to be dying, the girls of Crazy Horse keep the high-flying pole dance alive for all to see. Of course there is plenty of lap dancing as well for those simply interested in a little bump and grind.

—Mike Ferro

"One more **drink** and
I'll be **under** the host."
– D O R O T H Y P A R K E R

Rules OF THE Lap Dance
Dos & Don'ts from a Private Dancer

Want to get the most out of your lap dance without pissing off your dancer? Follow these simple rules, written by a professional stripper for the discerning customer. Even regulars might learn a thing or two:

• **Tip well before the dance—at least $10 above asking price!** This money will go straight into the dancer's pocket. She won't have to split it with the club. Offer to pay more per dance and you're bound to get a little more.

• **Don't bend her ear unless you plan to buy a dance!** Even if you are going to buy one, please practice economy of speech. Do you hold up the line at the bank by telling the teller all your tales of woe? Save it for your shrink.

• **Sorry, honey, you're not going to rock her world.** Have you ever cum at work? Didn't think so. Always remember, first and foremost, she is at work. For you, going to a strip club may be a social occasion, a way to unwind, whatever, but the dancer is at work, not on a date with you. She may pretend to enjoy it, she may even let herself go a bit, but she will never have an honest-to-God true orgasm. Other thoughts are occupying her mind, such as: *How much longer is this song going to last?*; *Is my tampon string visible?*; or *I hope the bouncer who deals Vicodin is here tonight.*

• **Don't try to kiss her!** C'mon guys. It's selfish and utterly naïve to expect this kind of intimacy. She probably has a husband or a boyfriend (or even a girlfriend) and reserves her kisses for them, not you.

• **Don't try to finger-bang her the second she says it's all right to touch her!** Not all girls allow touching, but those who do for the right price mean EXTERNAL TOUCHING ONLY! If she wanted your finger inside any of her orifices, she would put it there (right after monkeys fly out of her ass).

• **Don't be an idiot and say any of the following, all of which she hears about 30 times an evening . . .** 1) "Not now, maybe later." 2) "Is it all about the money?" 3) "Do you ever get aroused during a dance?" 4) "Do you ever date a customer outside of here?" 5) "I'm making a movie about strip clubs." Her thoughts when you say these things: 1) Wishy-washy asshole, he can't even say "No." 2) Duh, I'm at work. Would you go to work if you didn't get paid? 3) Yeah, I get about as aroused as a gynecologist gets during a pelvic exam. 4) I'll say yes to make him buy a dance. 5) If I only had a nickel for every smarmy auteur who doesn't know jack about what really goes on here but thinks it's cute to exploit my life to lend his stupid film a sense of titillating profundity . . . —Dancer X

Garden of Eden

This fruit is too ripe Skippy!

529 Broadway (at Columbus Ave.), San Francisco; (415) 397-2596.
Open Daily: 6 p.m.–2 a.m.

Much to the horror of Christian fundamentalists the world over, the Garden of Eden still tempts visitors with its huge green neon sign on Broadway Street. If the sign isn't enough to lure you in, there's usually a scantily clad hoochie mama just outside offering a peak in. Problem is, most of the girls working at the Garden of Eden are about as tempting as slightly damaged brown apples left outside on a hot summer day. The club itself is small but nice, with brick walls and one small stage. There are a few good looking girls who will try and get you to "go to the back" with them for a $20 lap dance. As in every club in North Beach, the quality of the lap dance is entirely dependant on the girl working. Resist temptation to go with the first girl who offers you a dance. Take your time, watch the club, and get one with a girl who will give you your money's worth. After all, if you are going to take a bite of forbidden fruit, it might as well taste better than a moldy crab apple.

—CA

L.A. Gals

Bootylicious bodies in motion!

1046 Market St. (at Sixth St.), San Francisco; (415) 621-2236. Open Daily: 11:30 a.m.–3 a.m.

To say that things get freaky inside L.A. Gals is a bit of an understatement. Things can get positively nasty at this hoochie-fied club. If you have a thing for ethnic girls, this is the place for you. Despite the blonde girl on the poster advertising the club on busy Market Street, you're more apt to meet a Beyoncé or Brandy look-alike at this hotspot. The main stage is lit by a spinning disco ball and flanked by a purple, graffiti-style SF skyline on the wall. There's a smaller stage in the back where XXX movies play and live girl-on-girl action takes place. The Hispanic, Black, and Asian girls who work here are definitely not shy, and they will practically grope you in an effort to separate you from your wallet in one of the back theme rooms. These have names like "Cleopatra's Lair" and windows that actually fog up for privacy (once you put money in the machine, that is).

What goes on inside, however, is entirely up to the dancer. Not all the girls here are lookers, and a few of them may actually be hookers, but all in all, L.A. Gals is an exiting slice of San Francisco smut for the serious pervert. Not recommended for couples, those with heart conditions, or Senate hopefuls.

—CA

Little Darlings

Put a little dent in your wallet…

312 Columbus Ave. (at Broadway), San Francisco; (415) 433-4020.
Open Daily: 6 p.m.–2 a.m.

Things can get pretty hectic inside North Beach's Little Darlings on Friday nights. The small front room only has one stage, but the real action takes place in the back. There are over 10 private booths available for lap dances, toy shows, and Little Darlings' special "Whip Cream Delight," where you can eat whipped cream off your favorite showgirl for a 20-spot (insert lame "cherry on top" joke here). Billing itself as a New Orleans-style club, Little Darlings has average to stunning girls every night of the week. Make sure to bring a little extra cash if you want to see a raunchy girl-on-girl show in the back room, where a plush, red bed with ringside seats awaits high rollers. Daytime admission will set you back $11, while nighttime admission is $20. Although the club itself is quite small, the girls here generally know how to dance well, and are all too willing to make your experience a good one. Not the best club in the city, but one could do worse in North Beach than Little Darlings.

—CA

"Graze on my **lips;** and if those hills
be dry stray lower,
where the **pleasant** fountains lie."
— WILLIAM SHAKESPEARE

Peep Show Show-Offs
Exhibitionists Turn the Tables on Strippers

The majority of peep-show patrons pay to watch nude girls, but a significant portion of these men derive their thrills from performing various acts in front of their captive and naked audience.

Carol Queen, a sexologist and former peep-show worker in San Francisco, describes a frequent customer known to the dancers she worked with as "Dildo Man." "He had a dildo with a suction cup on it, and he would stick it to the window, lube his butt up, and back right into it."

Dildos are not the only objects peep-show hams shove up their asses. "This creepy guy had a homemade plastic tube with a light in the middle," remembers Topaz, a San Fernando Valley, California, peep-show worker. "He put it up his anus, and then he shoved his ass toward me, and I could very clearly see the walls of his anal cavity."

Many dancers claim they don't mind these acts of exhibitionism because they break up the monotony of parading around nude in front of masturbating men all day. "My favorites are the real performance artists," says Erika Langley, peep-show dancer and author of *The Lusty Lady*, a photography book that chronicles the behind-the-scenes action of the peep palace of the same name in Seattle, Washington. "It's entertainment for us. I've seen a guy light his pubic hair on fire with a lighter. Then he kind of patted it out, and he was masturbating while he was doing it."

Occasionally patrons go too far and the dancers have to call security. Queen recalls an unusual customer as a show-off. "The first thing he did," she remembers, "was come in and show me photos of him and his girlfriend doing scat play. Then he did a little scat scene, and I was all, 'Sexologically speaking, man, that's really cool, but you can't smear that around here. I'm gonna have to ask you to stop.' "

Pissing in front of a young, naked girl is another peep-booth standard. "Guys would come in and urinate in a cup or a bottle," says Lilith, an ex-dancer at the Lusty Lady. "They would want you to watch them drink it. They'd want to see your reaction, and frankly I just got bored; this isn't really sexy to me. It could be that their fetish was just so weird that they couldn't get it taken care of at home—and I can respect that."

—Dan Kapelovitz

Performance | Strip

Pave Paradise & Put Up a Parking Lot
A Former Dancer Recalls a Legendary Strip Club

147 Mason Street is a rubble-filled hole, waiting to be paved over into yet another parking lot, but until recently it was home to the all-nude Chez Paree. I danced for three years in this unassuming club known for its leg-shaped neon sign; it wasn't the only club I worked at, but I never tired of its cabaret-like charm, the diversity of the strippers, and the unusual camaraderie between the dancers.

Chez Paree resembled a large basement rec room with a stage in the corner. Save for two little plug-in units on the stage (which was decorated with a tree and two reindeer at Christmas), the club had no lighting. The dancers picked their music off of a jukebox that offered an atypically eclectic range of music—everything from Nancy Sinatra to Massive Attack.

Chez Paree's style attracted a wide and interesting and diverse mix of dancers. They had a girl for almost any taste from au naturel to exorbitant artifice, from skinny to Rubenesque, from the girl next door to the grungy punk rocker. We liked dancing at the Chez because it was laidback—we could take breaks and work as hard (or not) as we wanted.

The stage shows ranged from awkward and mundane to spectacular and inspired. Conversation was frequent and ample; interaction at the Chez wasn't always limited to the hit-and-run "Want a dance?" so common at other clubs.

The main lap dancing area was a series of booths lining the hallway to the restrooms. Each booth had a padded bench (or a plastic chair for the unlucky). The candlelit booths offered a certain degree of privacy if you could ignore the clattering of platform heels heading to the bathroom, the whispering and chattering in the booth next to you, and the occasional opening of the curtain when a girl tried to use an already occupied booth. Lap dances were given bikini-clad or fully nude, and ranged from mild to wild.

As time went on, the cabaret turned into a dive. As stage fees went higher, so did frustration and competition. The old-timers left and took their creativity and spirit with them. Some stayed a little too long, dancing with fewer coworkers and even fewer customers. The charm was gone and everyone knew it.

It's odd that the Chez Paree is gone, but not sad. The true Chez Paree fizzled out long before the building was torn down. I missed it even when I still danced there.

—Amanda X

The Lusty Lady

Naked chicks for 25 cents!

1033 Kearny St. (at Columbus Ave.), San Francisco; (415) 391-3991;
Open Daily: 24/7.

While those who don't know any better are spending all of their hard
earned scratch just to walk through the front doors of San Francisco's
more upscale gentleman's clubs, rakes and rogues such as myself prefer
slumming it at the Lusty Lady. Located off Broadway in the shadows of
the Hustler Club, this dimly-lit peep show serves a decadent but faithful
few who have forsaken the bottle blondes and fake ta-tas next door for a
real taste of San Francisco. Not your typical strippers, the girls at the
female-run Lusty Lady are the same classy broads that you'll find in the
front lines of a pro-choice rally armed with coat hangers. (These girls
were also the first dancers to unionize in the U.S. as detailed in the
award-winning 2000 documentary film *Live Nude Girls Unite!*.) They're
big, they're bad, and they're unshaved—but then that's the whole fun of
going. And unlike pricey topless bars, the dolls at the Lusty Lady will be
happy to show you ALL their fun parts—and it will only set you back
one shiny quarter. Yep, live nude girls for the cost of a bubble gum ball.
So if you have some spare change in your pocket and can get past all
those opalescent puddles of love on the floor without slipping, the Lusty
Lady is a charming little shake shack that ought not be overlooked.

—Chevara Angeles

"Sex is like **air**...not important
until you're not **getting** any."
— DEBBIE REYNOLDS

"It's **not true** that I had nothing on.
I had the **radio** on." — MARILYN MONROE

Performance | Strip

Strippers Need Love Too!
Where San Francisco's Dancers Play After Work

Sure, it looks like strippers have a blast dancing to the latest P. Diddy joint while getting asked the same questions all night. But as any dancer worth her implants will tell you, she'd rather be dancing at the "real"clubs. Shocking, yet true. If you want to pick up a randy, up-for-anything girl in San Francisco, don't hit the strip clubs. Hit the clubs where the girls choose who gets a dance with them. So where do SF's finest dancers go to let off a little steam?

On any given night of the week, you will find a dancer at the infamous **EndUp**. The crowd may seem cracked-out on at this techno-barn, but the music is always tight, and the club is open all night so inhibitions flow freely here.

The **Backflip**, a notorious nightspot (attached to the even more notorious Phoenix Hotel), is a virtual lock to meet a stripper. Local big time promoter Sebastien's Friday night "Spa" party especially seems to pack in the dancers. Of course, the added bonus of the hotel onsite really brings new meaning to the phrase "get a room."

One of San Francisco's largest nightclubs is **Ruby Skye**. It opened in early 2000 and filled a badly needed void for a humdrum downtown— but it is a bit on the cheesy side. Like many clubs in the city, Ruby Skye's scene varies from night to night depending on who the promoters are. Generally, weekends tend to be an older, scarier crowd hell-bent on wearing whatever designer duds they can get their hands on. On weeknights, the velvet rope gets lifted for a younger, more party-friendly crowd. Watch out for bartenders that overcharge for drinks and Eurotrash in Armani turtlenecks.

You know the "alternastripper." Every strip club has at least one. Dyed hair, a few well-placed tattoos and piercings, and a sassy attitude to match, these girls all seem to end up at **Cat Club** on their nights off. Wednesday nights means "Bondage-A-Go-Go" (see p. 92) for the Gothic-industrial freaks, and Friday nights at Cat Club can only mean "Fake": a flesh-fest for the hipster-electro set. Clothes can, and do, come off when SF's most exhibitionistic girls take control of the Cat Club stages on crowded nights.

—CA

See next page for club digits.

18

The Club Digits:

Backflip: 601 Eddy St. (at Larkin St.), San Francisco; (415) 771-FLIP (3547).

Cat Club: 1190 Folsom St. (at Eighth St.), San Francisco; (415) 431-3332.

The Endup: 401 Sixth St. (at Harrison St.), San Francisco; (415) 357-0827; www.theendup.com.

Ruby Skye: 420 Mason St. (at Geary St.), San Francisco; 415-693-0777; www.rubyskye.com.

Market Street Cinema

See the beauty? Touch the magic? Sure!!!

1077 Market St. (between Sixth St. and Seventh St.), San Francisco; (415) 255 1005; www.msclive.com. Open Daily: 11 a.m–4 a.m.

This club's well-deserved infamy comes from the dancers' no-nonsense attitude; they correctly assume that most of the clients are not there to soak up the "atmosphere." Interactivity (when accompanied by cash) is encouraged. The girls run the gamut and will accommodate just about every imaginable taste. In the unlikely event that satisfaction can't be negotiated in the main arena ("wall dances" anyone?), by paying another cover for the Sin City area in the back greater degrees of privacy can be attained. The upstairs is generally very private as well. A tip for the savvier consumer—everything is negotiable and depending on how busy the girls are, what your breath smells like, and how bored/broke the girl is, bargains generally abound at the legendary MSC.

—Dick Deluxe

"Home is **heaven** and orgies are vile, but you need an **orgy** once in a while."
— O G D E N N A S H

The South Bay Swirl

Whether you're on the peninsula for business or are just looking to get away, make your South Bay experience pleasurable with one of these sexy diversions between San Francisco and San Jose.

Brass Rail: A venerable South Bay institution, this blue-collar heaven is a great place to unwind with a few drinks, shoot some pool, and check out the four stages of bikini-topped girls shaking booty. The dancer/waitresses function more as psychiatrists than sex objects to the regulars who pour their hearts out to them. 160 Persian Dr., Sunnyvale; (408) 734-1454.

The Candid Club: In yet another testament to local laws surrounding alcohol and nudity, this particular room has more of a sports bar feel, and it is not uncommon for Barry Bonds to get more attention than some of the comely gals plying their trade. The club sports a full bar and a pool table—no cover ever and worth every penny! 1053 E. El Camino Real, Sunnyvale; (408) 246-3624.

The Hanky Panky: An ethnic delight where beautiful latinas demonstrate their talents on an unusually large stage. The private dance areas have an unfortunate resemblance to the pens animals are kept in at county fairs, but the girls exhibit good cheer. Even though contact is a no-no, good value can be had for the savvy consumer and it's a great place to practice your Spanish! 2651 El Camino Real, Redwood City; (650) 366-4031.

The Hip Hugger: Beer, hot dogs, bored girls, and an atmosphere redolent of low ambition. Not to say some fun can't be extracted from this curiosity located between a plethora of rug wholesalers, dry cleaners, and fried chicken chains. There's no private dancing allowed, but a little frolicking is possible. Some good tattoos, some bad tattoos—catch the drift? 948 W. El Camino Real, Sunnyvale; (408) 736-8585.

Kit Kat Club: Come to the Kit Kat if only to see the curiously appointed room; Elvis and Larry Flynt must have collaborated on the décor. Some of the nekkid girls are world class, others are…not. Don't be surprised to see Burt Reynolds or his spiritual brethren show up in a leisure suit with gold chains. Keep an eye open for moving objects in the lunch buffet! 907 E. Arques Ave., Sunnyvale; (408) 733-2628.

Pink Poodle: Big-time porn stars on the circuit often make their hay here while on the road. There are some pretty house girls and the usual soda pop hustle. Don't piss off the bikers: they proved their mettle a couple

years ago by beating a recalcitrant customer to death in the lobby. An adult bookstore is available next door for one-stop shopping. 328 S. Bascom Ave., San Jose; (408) 292-3685.

T's Cabaret: T's is primarily a blue-collar joint dedicated to after-work hell raising with three stages, a full bar, and a separate VIP lounge. The cute girls get as friendly as the arcane California laws governing drinking and semi-nudity allow. Cheap cover, relatively inexpensive drinks, and a laid-back atmosphere make this a lowbrow favorite. 1984 Old Oakland Rd., San Jose; (408) 453-3066.

—Dick Deluxe

Mitchell Brothers O'Farrell Theatre

Ground zero for American strip clubs.

895 O'Farrell St. (at Polk St.), San Francisco; (415) 441-1930; www.ofarrell.com. Open Daily: 11:30 a.m.–2 a.m.

If you are a porn history freak, you know about the Mitchell Brothers world-famous show club. The Mitchell brothers are famous for many things, including their classic X-rated film *Behind the Green Door*. Their story was recently made into the film *Rated X* starring Charlie Sheen and Emilio Estevez. Our advice? Skip the film (Estevez blows!) and make your own history. Although the club has seen better days, they were the first to remove the glass so that dancers could interact with customers, and we are guessing that "Erotic Boxing" originated here (and it still rocks the club every Thursday, Friday, and Saturday night). The girls here are typically gorgeous and playful, and there are lots of theme rooms and nooks and crannies to get lost in for some one-on-one attention. The admission is still the highest in town ($30), but well worth it if you can afford to splurge or have a fat expense account. The club is couple-friendly and is a must-attend for every true San Franciscan.

—CA

"Is sex dirty? Only if it's done right."

– W O O D Y A L L E N

The New Century

The poor man's Mitchell Brothers makes good!

816 Larkin St. (between O'Farrell St. and Geary St.), San Francisco; (415) 776-0212. Open Mon–Thurs: 11:30 a.m.–3 a.m., Fri–Sun: noon–2 a.m.

In the shadows of the better-known Mitchell Brothers Theatre lurks the New Century. Recently aligned with the good folks at Déjà Vu, the New Century has made something of a comeback in recent years. On any night of the week, you'll find a bevy of beauties working hard to earn your dollars. There is a large main stage where the girls dance well to current hip-hop jams as well as 15 private theme rooms for lap dancing and those ubiquitous "extras." The sound system here is one of the better ones in the city and the club pulses with energy every night. You are apt to get a much better deal at the New Century than at the Mitchell Brothers' joint around the corner—especially if you visit during the day. Check the local daily newspapers for coupons waiving the $20 admission charge and really put that 20-spot to use in the plush backrooms of the New Century.

—CA

Roaring 20s

Nasty!

552 Broadway (at Columbus Ave.), San Francisco; (415) 788-6765. Open Daily: noon–2 a.m.

This must be where first-time strippers get their sea legs in North Beach. One of the more downscale clubs in the city, the Roaring 20s should be called the Whimpering 20s. It seems like they'll hire anyone, regardless of her ability to dance. The central feature of the club is the long, oval stage with two poles and a bad light show. Lap dances start at $20 for a dancer in a bikini and $30 for a naked one. Private rooms are upstairs with names like the "Swinger Room," the "Alcatraz Room," and the "Flapper Room." Don't bother insisting on a particular room—they're all the same. The club is small and there are often more girls patronizing it than guys. Even though these aren't the best looking girls in the city, they will get totally naked for the right price.

—Kelly Lewis

Contents

26 **Sex Toys and Novelties**

27 Cinderella Would Die for This Dildo: From *Art For Sex*, by Anne Marino

29 Where Would a Girl be Without Her Dick?: From Vixen Creations, by Cara Bruce

30 **Porn Shops: Mags, Books, & Videos**

33 Hard as the Rock: Pornographic Alctraz, by Charlie Amter

34 A Picture Worth 1,000 Dirty Words: San Francisco's Fetish Photographers, by Cara Bruce

35 **Arcades and Theaters**

37 Can't We All Get Along?: *Spectator* Versus *Yank*: The Feud Continues, by Charlie Amter

38 Surrogacy: Hands-On Sex Therapy, by Lisa Montanarelli

39 **Lingerie for the Lovelies**

42 **Stripper & Street Wear for the Sultry**

43 The Porn Star Next Door: An Interview With Adult Star Suzi Suzuki, by Charlie Amter

44 Have Your Cake and Eat It Too!, by Cara Bruce

CONSPICUOUS CUMSUMPTION
Shopping

In San Francisco, shame may as well be a city in China; hundreds of see-through mesh tops, naughty vibrators, and skimpy lingerie sets are sold daily and no one bats an eye. From Fisherman's Wharf to SOMA to Haight Street, there are plenty of places that can help you cross every item off of your sex shopping list. Even in a down economy, you can almost hear the "ka-ching" of cash registers mixed in with the steady purr of vibrators sold over the counter with a smile.

For the sleazy there's Haight Street, which moves the most merchandise of San Francisco's shopping districts. If you manage to avoid the trust-fund hippies on vacation from their rich parents in Marin County begging for change, you too can find that fabulous trashy outfit that will drive him (or her) wild. Get a nipple piercing or two while you are at it to complete your porn star transformation on SF's most famous shopping street.

But San Francisco isn't just for the trashy ho in you. Streets like Fillmore and Union offer high-end lingerie imported from Milan and Paris. A little class never hurt anyone, and you can buy it by the frilly, lacy armful at San Francisco's finest boutiques.

And of course, if you are looking for filthier pleasures, check one of the XXX video stores, adult novelty shops, and dildo specialists that keep San Francisco buzzing with pleasure. This is a town that knows how to get its jewelry and toolery out. So play on playa, swing it sister, and shop 'till you drop those lacy, racy, or leathery pants!

Big Al's

If you want it, Al's got it.

556 Broadway (at Columbus Ave.), San Francisco; (415) 391-8510. Open 24/7.

Don't let the flashing neon confuse you—this isn't a strip club; it's just where strippers shop. Stiletto heels, feather boas, and the trashiest lingerie this side of Sleazeville are proudly displayed alongside novelty items such as porn star blow-up dolls, pocket pussies, high-end items like the Rabbit Pearl vibrator, cock rings, penis pumps, loads of lube, and every conceivable dildo. Videos and DVDs are also for sale and available for preview for the standard $7 (plus $3 in tokens to enter the private arcade). If you're having a party, this is the place to get your X-rated booby water gun and anything cock- or tit-shaped. If you find sex toys frivolous or if you are entirely without a sense of humor, then you won't find Big Al's all that interesting. But for those who take their pleasure seriously, Big Al's has the best selection of toys and sexual aids in town.

—CB

Frenchy's Video

Oui, we carry anal sleeves!

1020 Geary St. (at Polk St.), San Francisco; (415) 776-5940. Open 24/7.

Most everyone in San Francisco knows Frenchy's Video—even if only for their notorious signage advertising salacious treats to rush hour commuters on busy Geary Street. Once inside the famed porn palace, you'll find a bit of everything for your inner freak—lotions, lubes, "anal sleeves" from your favorite porn stars, a large adult magazine selection, gay and straight videos, dildos, and vibrating vaginas. There is also a downright sleazy backroom arcade where gay men prowl at all hours hoping for some action. It's a bit uncomfortable in the arcade if you are straight and desire any sort of privacy, but overall, Frenchy's is a fine place to explore the edgier side of San Francisco smut.

—CA

"How do you **keep** the sex fresh?
Put it in **Tupperware.**"
— G A R R Y S H A N D L I N G

26

Cinderella Would Die for This Dildo
From Art for Sex

Or should that be artful sex? Either way, you'll become a life-long patron of exquisite sexual artistry when you spend an evening (or morning, or afternoon, or all day) with one of these acrylic, hand-sculpted, rapturously smooth dildos. Oakland dildiér **Cate Cannon** makes these extraordinary creations individually from the highest grade, rock-hard acrylic stock. For over 10 years, her exceptional repertoire of dildos has brought her clients to their knees in ecstasy. Cannon pays attention to every detail; her exceptional consultation includes specifying shape, size, contours, and color. These dildos are no fly-by-night affairs; they're a luxurious investment in your sex toy collection. They are durable, easy to clean, and easy to care for. Whether you want a petite piece that can fit into your evening purse or a late-night dildo to use with your favorite lover, Cannon's creation will exceed your expectations. No sophisticated guy or gal should be without a one-of-a-kind Cannon creation. Make an appointment today and find out why these toys receive four stars.

—Anne Marino

Art for Sex: (510) 436-6861; www.artforsex.com.

Good Vibrations

The Martha Stewart of sex shops.

1210 Valencia St. (at 23rd St.), San Francisco; (415) 974-8980; www.goodvibes.com Open Sun–Wed: noon–7 p.m., Thurs–Sat: 11 a.m.–8 p.m.

Wondering where that hot girl you met last night got her strap-on? Since 1977, Good Vibes has supplied everyone from strippers to soccer moms with an enormous array of sex toys, erotica, how-to guides, and adult videos. This female-owned, sex-positive store caters to women and promotes open communication about sex. A far cry from the stereotypical backroom porn joint, Good Vibes offers a wide range of educational workshops and has enough vibrators on display to shake the whole block. With a unique mix of radical feminist sex and upscale boutique atmosphere, Good Vibes is tasteful enough to please your mom and kinky enough to make your toughest dyke pal blush.

—Lisa Montanarelli

Also at 2504 San Pablo Ave. (at Dwight Way), Berkeley; (510) 841-8978.

House of Ecstasy

Who wants to buy a masturbating monkey?

1043 Kearny St. (at Broadway), San Francisco; (415) 362-5405. Open Daily: 10 a.m.–2 a.m.

You know the drill by now: Walk in, marvel at the selection of dildos, and laugh at the suckers who actually plunk down $100 for a high-tech blow-up doll. This shop has everything you'd expect and then some. The novelty selection is especially good and includes wind-up masturbating monkeys. And in the tradition of seemingly every shop in North Beach, magazines and videos are also for sale. This is a fun, couple-friendly, and safe bet for a drunken laugh in North Beach.

—CA

> "If it is the **dirty element** that gives pleasure to the act of **lust**, then the dirtier it is, the more **pleasurable** it is bound to be."
>
> — MARQUIS DE SADE

Frontlyne Video

Home of the dollar a day video rental...

1259 Polk St. (at Bush St.), San Francisco; (415) 931-9999. Open Daily: 10 a.m.–11:30 p.m.

Frontlyne Video is something of an institution in the notorious Polk Gulch. Posters of recent Hollywood blockbusters adorn the outside of the shop, but the true nature of this beast of a video store lies inside—thousands of XXX titles leap off the shelves. Although they do carry many "normal" Hollywood videos (many for $1 a day), the bulk of their videos are hardcore titles. From amateur to gay to gangbangs to Japanese bondage videos, Frontlyne has it all at a decent price. It's no surprise the place is always buzzing.

—CA

Where Would a Girl be Without her Dick?

From Vixen Creations

Whether you like them long or short, pink or blue, curved or straight, **Vixen Creations** has a sort of monopoly on the San Francisco sex toy scene. Their high-quality dildos are made only from silicone, are individually handcrafted, and they're guaranteed for life. What other sex toy maker on the planet boasts that?

A one-time employee of **Good Vibrations** (wasn't everyone in San Francisco?), Marilyn Bishara saw the "hole" in the dildo market—women loved silicone dildos. The few that Good Vibrations carried flew off the shelves, and Bishara saw a business opportunity. Since 1992, Vixen has flourished, providing silicone sex toy nirvana to stores across the world. Female-owned and operated, it is one of a handful of companies in the business of sex that guarantees its products and honestly cares about customer satisfaction.

Their custom-made dildos have costarred in many adult films. The "Bobbi Sue" (doesn't Vixen name them well?) debuted in *Bend Over Boyfriend 1*, and sex goddess and *Village Voice* columnist Tristan Taormino made anal history with her custom, Vixen-created "Tristan" butt plug.

But Vixen is far from just the best sex toy maker on the planet. Each year they donate thousands of dollars to various gay and lesbian groups, sex positive events, leather events, breast cancer awareness, club openings, and more.

Their web site boasts an online store, including an imperfections page. These girls demand 100% perfection—even if the color is off a bit you may be able to get your toy for as much as half of the regular price. So even babes on a budget don't get screwed, or in this case, I guess they do!

—Cara Bruce

Vixen Creations: *(415) 822-0403; www.vixencreations.com.*

"I feel like a **million** tonight— but one at a **time.**" – MAE WEST

Shopping

Le Video

Bringing out "le freak" in you since 1982.

1231 Ninth Ave. (between Lincoln Way and Irving St.), San Francisco; (415) 566-3606; www.levideo.com. Open Daily: 11 a.m–11 p.m.

Definitely the best outlet in San Francisco for cult and adult titles in both VHS and DVD formats. Founded by a local Frenchwoman who was frustrated by a lack of French vids in our fair city, Le Video has been expanding its selection of outrageous and erotic movie rentals for over 20 years. Shelves (sometimes entire aisles!) are devoted to such mondo genres as women in prison, Japanese exploitation, Nazi exploitation (one popular title is *Last Orgy of the Third Reich*), as well as skin-filled European slasher/zombie/cannibal features, works by infamous directors like Russ Meyer and Jesus Franco, and many more. The unique Hall of Porn is arranged by category (anal, gangbang, black, Asian, gay, all-girl, busty, orgy, classic), as well as by porn star. If you're not into cult or smut, the joint is packed with close to 75,000 VHS movies and nearly 7,000 DVDs (including an amazingly eclectic foreign film section). In fact, their most popular rental is director Rob Reiner's non-mondo romantic comedy, *The Princess Bride*. So there!

—Anthony Petkovich

"Women need a reason to have sex—
men just need a place."
— BILLY CRYSTAL

The Magazine

Buying, selling, and collecting porn for 28 years.

920 Larkin St. (between Geary St. and Post St.), San Francisco; (415) 441-7737. Open Tues–Sat: noon–7 p.m.

This is one of San Francisco's best kept secrets. Owners Trent Dunphy and Robert Mainardi have amassed one of the finest collections of vintage porn magazines dating back to the 1970s. Forget eBay—if you are looking for old editions of *Playboy*, *Hustler*, even Swedish erotica magazines, chances are The Magazine has what you want. In addition to gay

and straight adult magazines, there is also has a wide selection of books, videos, comics, 8mm porn(!), and back issues of consumer magazines like *Details*, *Maxim*, *Wallpaper*, and *Vogue*. The well-informed staff will also buy magazines and videos for $2 and up with an eye skewed toward "well-preserved" adult material. Don't be a-bringin' your nasty mags from the 1980s with the pages stuck together. There also may or may not be a thriving gay pick-up scene at the store—as it is nearly always crowded with well-dressed men "browsing."

—CA

North Beach Movies

Not for the faint of heart.

1034 Kearny St. (at Broadway), San Francisco; (415) 391-1073. Open Mon–Sat: 10 a.m.–midnight, Sun: noon–midnight.

The sign above North Beach Movies screams "Nastiest Videos in Town" to frightened tourists passing by. They aren't kidding either. Specializing in rare European bondage, amateur, and scat videos, the vibe at North Beach Movies is definitely hardcore. Scary collector types can be found browsing the videos here (many in plain white plastic boxes) with scowls on their faces. But if you are simply dying to find that Nu-West/Leda title (*Enema Discipline* anyone?) then North Beach Movies is your bag, baby. Prices tend to be higher here, with many extreme-kink rentals going for $10 and the videos cannot be taken home but must be watched in the store after they are "rented." They do sell videos here, but the prices are sky high. A small arcade is located in the back for those who simply can't wait to view their hardcore smut.

—CA

"You know of course that the **Tasmanians**, who never committed adultery, are now **extinct**."

— W . S O M E R S E T M A U G H A M

Shopping

Top Video

Tom Cruise does not shop here.

888 O'Farrell St. (at Polk St.), San Francisco; (415) 567-7490. Open Daily: 11 a.m.–midnight.

Across the street from the world famous Mitchell Brothers Theatre, Top Video may have one of the best XXX video selections in San Francisco. Well-organized and clean, Top Video has everything, from out-of-print classic titles and hard-to-find European flicks to the latest from Elegant Angel. The occasional porn star will drop in for a signing from time to time, and Annie has the Polaroid's on the wall to prove it. They also have a large separate section for regular Hollywood flicks à la *Top Gun*, but we have yet to see anyone rent a "real" movie at Top.

—CA

Video Tokyo

Pixilated pussy on DVD!

282 O'Farrell St. (at Mason St.), San Francisco; (415) 296-7743. Open Daily: 10 a.m.–1 a.m.

One of the many confounding mysteries of Japanese culture is Japanese porn. By law (which our esteemed General MacArthur helped write), no genitalia can be visible in mainstream Japanese pornography. The result of this ridiculous law is some of the kinkiest XXX action you'll ever see—minus the pubic hair thanks to digital pixelation (which is that familiar checkerboard blur seen over boobs on cable TV). Naturally, many Americans find this fascinating and are drawn to Video Tokyo's massive selection of Japanese videos and DVDs. The folks at Video Tokyo aren't exactly thrilled to rent to *gaijins* (that means you whitey!), but if you don't ask too many questions, you can take home one of the hundreds of naughty Japanese videos.

—CA

"A lady is one who **never** shows her underwear **unintentionally.**"

— LILLIAN DAY

Shopping

Hard as the Rock
Pornographic Alcatraz

The magnetic lore of Alcatraz draws over 11 million tourists to San Francisco every year, and that mysterious aura has finally reached the porn industry—much to the chagrin of National Park Service officials. In the spring of 2002, under the cover of darkness, a mysterious director and a few aspiring porn starlets broke into one of the most heavily guarded tourist attractions on the West Coast.

Max Baylor, owner of Magic Fly Digital, the U.S. distributor for *Orgasmic Alcatraz: The Rock Gets Harder*, claims that even he doesn't know who the ballsy director of the underground porn is. "Although I don't know his identity," says Baylor, "his fetish is definitely extreme exhibitionism. He is crafty enough to get around the system in order to film." The nameless director is responsible for everything from kinky prison sex on the Rock to upcoming films in Magic Fly Digital's "Rich and Fetish" series which include footage of fornication inside the Louvre in Paris and raucous sex inside Egypt's pyramids.

Although not every scene in *Orgasmic Alcatraz* was shot on location, there are enough steamy shots to piss off the National Park Service and their honchos who were caught sleeping on the job. "We can't comment on that security breach," says Rich Weideman, Alcatraz's spokesman for the National Park Service. So how did the renegade filmmakers sneak a bevy of nymphettes onto the island to shoot the porn? "They posed as fisherman," explains Baylor.

One scene in particular undoubtedly roused a few of the ghosts of Alcatraz, as two raven-haired nymphs wearing nothing but high heels and nipple piercings pose as "guards" within Alcatraz's famous base-ment jail cell, "punishing" the poor "inmate" until he explodes. When the renegade porn stars left Alcatraz that foggy night they left more than their hearts in San Francisco; they left a sex-soaked, law-breaking legacy for all to see on DVD.

—Charlie Amter

For more information and your chance to be extra in upcoming under-ground porn flicks shot in other famous landmarks throughout the world, go to www.richandfetish.com.

Shopping

A Picture Worth
1,000 Dirty Words
San Francisco's Fetish Photographers

Back when a tattoo pegged you as a convict and colored hair meant a bleach job gone horribly awry, San Francisco's fetish photographers were already documenting these forbidden, underground communities. Over the decades, these trail-blazing artists have helped these taboos become acceptable, and today, you can get your belly button pierced in the mall and show it off at Grandma's house.

World-renowned San Francisco fetish photographer **Charles Gatewood** (www.CharlesGatewood.com) chronicled the Satanic Apache Rituals in the first blood fetish book. Gatewood was the first American to document the fetish known as "sploshing," where women cover their bodies in oil, mud, and cake batter (check his book *Messy Girls*). He also runs Flash Productions, a video company that has produced many videos on fetishes and other oddities.

Eric Kroll (www.EricKnoll.com) was a photojournalist who became interested in fetish photography in the late 1980s. He began by photographing women in bondage and has now expanded his subject matter and mediums (he produces videos too). S/M cuties, masturbation mavens, shaving gents, rubber whores, and contortionists are all subject to his lens.

Photographer **Phyllis Christopher** (www.PhyllisChristopher.com) has the lesbian scene firmly in her pocket, largely because of her controversial "pee" photos, which came long before magazines like *Hustler* started featuring golden showers on every page. Her dykes are exhibitionists who wear leather, practice S/M, and yes, they piss on each other.

Creating fetish photography in San Francisco since 1977, **Michael Rosen**'s (www.MichaelRosen.com) success is growing steadily. Using real people rather than models, he covers sexual ritual, S/M, and gender play with style. In his book *Sexual Portraits*, he entered exclusive communities and photographed everything from Wiccan ceremony to ritual piercing.

Writer and photographer **David Steinberg** focuses on real couples having sex at home. His photos focus on intimacy, play, passion, small gestures, moments of surrender, faces, and hands more than genitals (though there are plenty of graphic genitals, too).

—Cara Bruce

Adult Media

Your husband shops here.

700 Kearny St. (at Clay St.), San Francisco; (415) 391-5163. Open Daily: 10 a.m.–2 a.m.

When the financial markets close in the early afternoon, downtown's Adult Media's business really picks up. Proving that porn knows no socio-economic boundaries, well-dressed men in $900 Armani suits browse through XXX titles like *Can I Fuck You, Too?* and *Jail Babes* right next to quasi-homeless pervs in tattered T-shirts. The DVD selection is especially good, as even pornophiles like their smut in the newest form technology has to offer. It's also a lot easier to slip a thin DVD in your laptop bag where the wife or uptight girlfriend can't see it.

—CA

Don's of Sixth Street

Get down with "the Don."

111 Sixth St. (at Mission St.), San Francisco; (415) 543-1656. Open Daily: 9:30 a.m.–11:30 p.m.

Since 1968, this shop has quietly been providing the disheveled, downtrodden, LSD-tripping, heroin-slamming, strung-out, coked-out, cracked-out dope fiend population of San Francisco with quality porn. This XXX Video Arcade features 200 channels and makes most of its money in $1 tokens. The sign on the counter reads "20 minute browsing limit strictly enforced" and for the most part it is. I'm not sure if it was Don behind the counter when I visited, but he was nice, knowledgeable, and helpful. Don's has a wide selection of fetish videos—everything from midgets to wrestling to grannies to fat. The novelty toys compile the most interesting section in the store; the life-size fist was so scary I almost had to get one and the Little Bo Peep vibrator gave me nightmares for weeks. They even carry clocks with different animals butt-f***ing to the time—one of the most original novelties I've seen yet. Even if jacking off in a jizz covered booth isn't really your bag, pop in to talk to the owner and check out the selection—definitely one the best arcades in the city.

—CB

"It's **so long** since I've had sex,
I've forgotten who **ties up** whom."

– J O A N R I V E R S

Shopping

Golden Gate Video

If you dare...

99 Sixth St. (at Mission St.), San Francisco; (415) 495-5573. Open 24/7.

To say that the corner of Sixth and Mission is seedy is like saying Coit Tower looks a little phallic. Sixth and Mission is the premiere corner for the down-and-out of San Francisco, but despite being in the thick of it, Golden Gate Video is surprisingly clean. The staff has watched this particular corner go even further downhill than they thought possible since they opened 10 years ago, but the neighborhood is making a comeback thanks to a few hipster bars that recently opened. There are 13 25-cent arcade booths at Golden Gate and six preview rooms that rent for $7 each. The store features video rentals and sales, novelty sex toys, condoms, lube, massage oils, and a selection of magazines. The old guy behind the counter was as nice as could be—or maybe he was just really stoned. But hey, if you worked that corner, you would be too.

—CB

San Francisco Dollhouse Cinema

*Welcome to the Dollhouse...would you like
your condoms buttered?*

80 Turk Street (at Taylor St.), San Francisco; (415) 673-2577. Open Sun–Thurs: 9 a.m.–11 p.m., Fri/Sat: 9 a.m.–2 a.m.

This adult cinema is a nod back to the olden times of porn. Open since the 1960s (yes Grandma, it's still standing), this 100-seat theater was recently renovated, and it's actually nice inside. Known as the old "Gaity" theater, the Dollhouse is located in an unassuming building in one of the worst parts of San Francisco. You may have to walk past half the homeless population of the city to get here, but it's worth it. The concession stand is stocked with popcorn, licorice, hot dogs, condoms, and lube— "manned" by a beautiful black transgender hostess. The theater shows three different movies a day, so if you love porn and want to waste some time, the Dollhouse is highly recommended. Inside it's dark enough to do what you want—just be careful where you walk and where you sit. I'm not sure how the pick-up action is, but any place that sells condoms probably expects you to use them.

—CB

Shopping

Can't We All Get Along?
Spectator *Versus* Yank: *The Feud Continues*

San Francisco has a history of nasty newspaper wars: the *Examiner* vs. the *San Francisco Chronicle*, the *San Francisco Bay Guardian* vs. *SF Weekly*. But the nastiest feud of all has to be the *Spectator* vs. the *Yank*.

The mud-wrestling match between the city's leading adult tabloids has been going on for a decade, and recently it rose from the mean streets to superior court. David Moreno, *Yank* magazine's publisher, has filed a wide-ranging lawsuit against the *Spectator*, charging the paper with everything from slander to vandalism. Moreno alleges that "agents" of the *Spectator* have been defaming his reputation and defacing *Yank* newsracks since he took over the paper about eight years ago.

The young publishers of the *Spectator*, Dara Lynne Dahl and W. Vann Hall, aren't taking such talk lying down. Hall notes Moreno's inability to produce any evidence of his claims and calls the *Yank* a "bizarre editorial mix of junior-high sexual fantasy, outrageously unbelievable true crime dispatches, and rambling, vaguely homophobic rants" while the *Spectator* is a "quality, sexually focused publication."

Indeed, for all their apparent similarities, the papers are very different. Bob Miller, co-owner of a Bay Area escort-and-massage listings service called Lovings.com, has advertised in both sheets. "*Yank* is a bit more hardcore and targets tourists near hotels; the *Spectator* is more of a politically aware paper for locals."

What the two papers have in common is an advertising base that consists overwhelmingly of phone sex and escort services and racy personals. Because such ads appeal to publicity-shy individuals, both papers also share a dependence on newsrack circulation (thus the fuss about vandalism of the racks).

Income at all adult papers has shrunk as advertisers have flocked to X-rated web sites. Hall says *Spectator's* annual revenue of "just shy of a million" barely pays the staff of seven full-timers and four part-timers. But when he tried to reconcile with Moreno, proposing a San Francisco lunch summit, Moreno refused.

Soon after came the lawsuit. Seems even those who espouse free love, or at least cheap lust, have forgotten the message of sharing.

—Charlie Amter

Wild J's

Release your inner wild thing here.

90 Turk Street (at Taylor St.), San Francisco; (415) 567-9191. Open 24/7.

Wild J's features the same stuff as the Art Theatre right across the street. They carry videos, DVDs, mags, toys, condoms, lube, and the multi-channel video arcade booths and preview rooms are the staple. It even looks like the shop right across the street. The only difference is Wild J's has a better name, a bigger selection, and is much roomier, lending important elbowroom to browsers.

—Dave Williams

Surrogacy
Hands-on Sex Therapy

Men from all over the world make the pilgrimage to San Francisco for surrogate partner therapy, also called surrogacy or sex surrogacy. Developed by William Howell Masters and Virginia Eshelman Johnson in the 1970s, it remains one of the most effective treatments for erectile difficulties, rapid ejaculation, performance anxiety, and many other sexual issues.

In most cases, the client sees the surrogate (usually a woman) between appointments with a therapist. Although some clients enter therapy with relatively simple mechanical issues, many clients have never had an intimate relationship. The surrogate teaches the client ways to combat performance anxiety by focusing the mind on bodily sensations along with social and sexual skills such as communication and sensual touch.

Many people confuse surrogate partner therapy with sex. The goal is therapy rather than entertainment. Although most surrogates are women who work with male clients, surrogate partner therapy is open to people of all genders and sexual orientations.

—Lisa Montanarelli

To inquire about surrogate partners in your area, contact the
International Professional Surrogates Association (IPSA):
P.O. Box 4282, Torrance, CA 90510; (323) 469-4720;
members.aol.com/ipsa1/home.html.

Alla Prima Fine Lingerie

A designer mix of functional and ultra-girlie.

539 Hayes St. (at Octavia St.), San Francisco; (415) 864-8180.
Open Mon–Sat: 11 a.m.–7 p.m., Sun: noon–5 p.m.

The Hayes Valley location of Alla Prima has a comfortable amount of shopping space for their sizable selection of recognizable Euro-brand names like Gemma (the stretchy, seamless foundations tailored to look good under clothing) and the more traditional Prima Donna (lacy, colorful Euro-inspired bra-and-panty sets). Most impressive is the well-stocked selection of coveted Cosabella lingerie, especially the array of thongs. Alla Prima also carries a limited selection of swimsuits, French soaps, perfumes, and artisan jewelry. Prices range from $50 and up for bras and $20 and up for panties. Make sure to check the sale racks on the balcony upstairs.

—Rebecca Anderson

Also at 1420 Grant Ave. (at Green St.), San Francisco; (415) 397-4077.

Carol Doda's Champagne and Lace

Champagne wishes and lace panty dreams.

1850 Union St. #1 (between Laguna St. and Octavia St.), San Francisco; (415) 776-6900. Open Daily: noon–6 p.m.

You would expect this Union Street location to be as upscale as the neighborhood, but, like the larger-than-life neon sign of Carol Doda's flashing breasts that used to light up North Beach, it comes off lovable yet tacky. Just off the main street, the store is nestled in a cute little alcove next to a bridal shop—which comes in quite handy since Doda's features a wide array of bridal lingerie. The shop is intimate (read: small) and full (read: unorganized). It reminded me of the sale rack at a favorite department stores. Frequented by both men and women, Doda's specializes in hard to find sizes, and the staff is helpful and down to earth. It may look a bit messy, but pick through and you will find some real gems at reasonable prices.

—CB

LINGERIE

Shopping

Chadwick's of London

Look absolutely fabulous positively naked.

2068 Chestnut St. (at Steiner St.), San Francisco; (415) 775-3423.
Open Mon–Fri: 11 a.m.–7 p.m., Sat: 10:30 a.m.–6 p.m., Sun: noon–6 p.m.

Chadwick's of London is as upscale as its name. The boutique has been in the Marina for nine years and thrives on customer referrals. Beautifully organized, this is one of those places that makes shopping for lingerie an "experience." The focus is on customer service—if you request something, they'll find it. Their collection features pieces by world-famous designers like Aubade and sexy items like those don't come cheap. Still, Chadwick's has the panties you might find in Hollywood's celebrity closets for those who gotta have 'em!

—Kelly Lewis

Les Cent Culottes

I see Sophie's underpants…

1504 Vallejo St., (at Polk St.), San Francisco; (415) 614-2586.
Open Tues–Sun: 11 a.m.–8 p.m.

Sophie Baudet's small shop off Polk Street specializes in French lingerie sets such as Barbara, Princess Tam Tam, and Chantelle. The collection is on the small side, but has obviously been amassed to offer maximum elegance and style. There is a nice range of styles from intricately embroidered, burgundy-and-silver lace pieces to simple silk and cotton sets. While their prices will prevent Les Cent Culottes from replacing Victoria's Secret for your everyday pretty things, it's the perfect place to find that special sexy something *pour votre amour.*

—Genevieve Robertson

My Boudoir

Your bedroom mirror will thank you.

2029 Fillmore St. (at Pine St.), San Francisco; (415) 346-1502;
www.myboudoir.com. Open Mon–Fri: 11 a.m.–7 p.m., Sat: 10 a.m.–
7 p.m., Sun: 11 a.m.-6 p.m.

If you are looking for intimate apparel on swanky Fillmore Street, look no further than My Boudoir. This bright and inviting store carries fantastic high-end Italian and French skivvies at prices that won't break the bank. For that "extra" special something to impress your lady (or man—this is San Francisco after all), My Boudoir is your one-stop shopping destination. The staff here is friendly, and they will help you select from their small, but well chosen selection of designer lines like Parah, Versace, Aubade, and more.

—CA

Romantasy Exquisite Corsetry

Don't get too close to my romantasy!

2912 Diamond St. (at Bosworth St.), San Francisco; 415-585-0760; www.romantasy.com. Open by appointment only.

After 13 years as San Francisco's corset couture provider, Romantasy, in keeping with the times, is now primarily an online business and the doors to their retail store have (sort of) closed. The corset-hungry public can't exactly linger with the lingerie, but anyone is invited to call and make a private appointment for a custom fitting. The proprietress is super-sweet and loves what she does. Corsets may be expensive, but most of us will only need one in our lifetime and isn't it worth getting one made just for you by the best?

—Kelly Lewis

Toujours

Where to buy your bridal trousseau.

2484 Sacramento St. (at Fillmore St.), San Francisco; (415) 346-3988; www.toujourslingerie.com. Open Mon–Sat: 11 a.m.–6 p.m., Sun: noon–5 p.m. and by appointment.

Tucked away on Sacramento Street, just off the main shopping area of the Fillmore District, Toujours is a tiny boutique with an irresistible closet-like appeal. The walls are hung with high-end underwear and nighties and resemble a fancy lady's personal collection of unmentionables. A few selections are available online.

—Rebecca Anderson

Shopping

Dal Jeets

Shoes, threads, and gear for naughty men and women.

1773 Haight St. (at Cole St.), San Francisco; (415) 668-8500;
www.daljeets.com. Open Daily: 11 a.m.–7 p.m.

Slip past the crowd of 14-year-old punks outside and dive into Dal Jeet's edgy world of men's and women's clothing, shoes, and sex accessories. Men's shoes range from punk-inspired to flame-encrusted platforms, and women's shoes by hot brands such as Delicious and NYLA are always stocked (some of the stilettos even come in men's sizes). For clothing, Dal Jeets is one of the few stores in the city that caters to the male persuasion, offering pimp and player shirts by Chochie Casuals among other brands. Ladies can pick up inexpensive tees by Hustler or the infamous Porn Star Clothing brand, and anyone over 18 can slip into the adults-only back room to browse the selection of cock rings, nipple clamps, spurs, and handcuffs.

—Margot Merrill

Fashion Exchange

From Russia with love dahling.

1444 Polk St. (at Sutter St.), San Francisco; (415) 666-9999.
Open Daily: 11 a.m.–8 p.m.

While many in the increasingly trendy Polk Gulch district have taken to calling this new-ish store simply and affectionately the "ho" store, Fashion Exchange has some great secondhand duds. True, tranny hookers can often be seen selling their smelly old Versace pants here for a 20-spot, there are also hidden gems galore at this cool consignment boutique. Gold lamé hot pants hang right next to that BCBG dress you've coveted for years. The Russian owners are fashion scene vets and know their stuff well; they refuse to buy any designer duds with tears or holes. So for just a few rubles, you too can bring home that smutty sequin top, perfect for a night of hooking out on the town.

—CA

"I'm such a **good lover** because
I practice a lot on my **own.**"

— WOODY ALLEN

The Porn Star Next Door
An Interview with Adult Star Suzi Suzuki

Suzi Suzuki was born in Tokyo, but has been a proud San Francisco resident for almost 10 years. One of the most recognizable names in porn, she has been a featured exotic dancer at clubs in Hong Kong, Greece, Canada, and throughout the United States. In San Francisco, Suzi now judges local porn and fetish events and does the occasional adult movie. We caught up with Suzi before her stint as a judge at the Ms. Nude San Francisco pageant.

Q: Why did you move to San Francisco?

A: I dreamed about the U.S. a lot growing up. I first lived in New York, but at that time it was very dangerous. I finally moved to San Francisco because it has a very similar feeling but it's safer and easier to live in. It was also cheaper here 10 years ago! I really moved here to work with the famous adult director Nick Deranzee.

Q: What makes San Francisco sexy to you?

A: A lot of things! I love the different ethnicities of people here. You can go to North Beach and see people from Italy, or you can go to Chinatown and eat real Chinese food. And of course I love Japantown! I also like to go to see friends dance at local strip clubs when they come through town.

Q: How many movies have you done?

A: Over 150. That's not as much as other girls though!

Q: Do you have a lot of fans in San Francisco?

A: I have a lot of fans in the Bay Area who know me from when I danced at Market Street Cinema. They are very loyal. I try to be friendly and personal with them.

Q: Where do you buy your sexy, see-through outfits?

A: I like to shop at Piedmont on Haight Street. It's kind of a funny store for drag queens, but I like it a lot. I also like Leather Etc. I model for them sometimes.

Q: What's the craziest place you've had sex in San Francisco?

A: Aside from the Power Exchange? This sounds crazy, but there is a restaurant near Cannery Row by Fisherman's Wharf where they have a waiting area that looks over the water. They have some chairs there but you have to be quick—it gets crowded on Friday nights!

—Charlie Amter

Shopping

Have Your Cake
AND Eat It Too!

Need something for the person who has everything? Why not surprise him or her with life-size chocolate breasts or a marzipan dildo? Imagine the tears of joy on her face when you light the candles on their penis cake! If your mouth waters at the thought, an erotic dessert may be in your future. If you're not feeling especially creative, most of these retailers have samples you can flip through for some creamy inspiration.

—Cara Bruce

Cake Gallery: 290 Ninth St., (west of Folsom St.), San Francisco; (415) 861-CAKE (2253).

Naughty Cakes: order one at www.NaughtyCakes.com or call (866) 772-CAKE (2253).

Satisfy the sweetest tooth with carnal candy from:

Chocolate Fantasies: order at www.chocolatefantasies.com or call (800) 595-9936.

Erotic Chocolate Shoppe: order at www.eroticchocolates.com or call (888) 848-0844.

Felicity's Fetiche

Where every outfit comes with a matching thong!

1214 Sutter St. (at Polk St.), San Francisco; (415) 474-7874.
Open Mon–Sat: 11 a.m.–7 p.m., Sun: noon–6 p.m.

The inviting logo proudly emblazoned on Felicity's sign is a wonderful synopsis of this fabulously slutty little boutique: "Apparel for the Showgirl in You." Tucked as discreetly as a condom in the pocket of one of San Francisco's seamier neighborhoods, Felicity's Fetiche boasts the best selection of next-to-nothing wear in Polk Gulch. Mesh thong-and-bra duets in every color imaginable line one wall; hand-beaded theme costumes and peek-a-boo dresses fill out the rest of the small store. There is a deference to the classic fetishist here marked by a large selection of shiny vinyl to squeeze your ass into. The environment is as warm and friendly as Felicity herself; you don't have to have a rib removed to

feel like the gorgeous slut you know you are. Be brave; try something on…you may be pleasantly surprised by your reflection looking lasciviously back at you!

—Rachel Blado

Foxy Lady Boutique

I wanna take you home…

2644 Mission St. (at 23rd St.), San Francisco; (415) 285-4980. Open Mon–Thurs: 10 a.m.–6 p.m., Fri/Sat: 10 a.m.–7 p.m.

Whether you're on the prowl for a slutty little outfit or some vintage mod shades, when you're in the Mission District Foxy Lady is a must-shop stop. Owned by a charming San Francisco dancer from "back in the day," Foxy Lady has a huge selection of sequin tops and bottoms, funky hats, ghetto-fab glasses, lingerie, and a gloriously diverse smattering of smutty and naughty items. Hipsters shop here, but so do hookers, and that, my friends, is the beauty of the Mission District in a nutshell.

—CA

Lusciouswear

Hope you have a luscious line of credit.

1410 Polk St. (between Pine St. and California St.), San Francisco; (415) 440-0172. Open Mon–Sat: 10 a.m.–6 p.m.

This Polk Street boutique has been around for quite some time and has always been a favorite of Polk Gulch trannies as well as curious gals in the 'hood. The prices are a bit high here, and for an unknown reason considering the craftsmanship of the clothes. Yes, there are a few variations of boobless bras and see-through nighties with marabou trim, but not enough to get excited about. There is a rack of tall shoes, but nothing that you can't find somewhere else. The owner tends to be pushy and it is hard to just look around in this tiny, almost claustrophobic space. My advice: if you feel like spending more than you know it's worth for the brocade corset, go for it. But you could definitely have more fun looking for lingerie elsewhere.

—Rachel Blado

Shopping

New York Apparel

Sexy punk basics, Big Apple-style.

1772 Haight St. (at Cole St.), San Francisco; (415) 751-8823;
www.nyapparel. Open Daily: 11 a.m.–7 p.m.

This small, fluorescent-lit boutique could indeed appear on any down-
town New York City street and carries all the punk and S/M basics. What
it lacks in ambiance, New York Apparel makes up for in volume; from
thongs and panties, an entire wall of fishnet stockings, and plenty of
spiked collars and belts, to "foundation garments" such as black vinyl
evening dresses by Leg Avenue, sexy plaid miniskirts that scream
"Smutty Britannia!", and men's bondage pants by Lip Service. New York
Apparel is the store where the strippers, offbeat locals, and adventurous
tourists can pick up all the necessary basics for their slutty street wear
wardrobes.

—Margot Merrill

Piedmont Boutique

From Monroe to Manson and everything in between.

1452 Haight St. (at Ashbury St.), San Francisco; (415) 864-8075;
www.piedmontSF.com. Open Daily: 11 a.m.–7 p.m.

Ever since the Piedmont Boutique opened its doors in 1972, the world
has been reeling—and lusting after its plush abundance of one-of-a-kind
accessories. The original owners—married couple Uti and Sahaj—
ensure that whatever your fantasy may be, you leave beaming with the
knowledge that no one else has your particular outfit. Almost everything
in the Piedmont Boutique is custom-made for the store. Uti and Sahaj
carry more wigs, costume jewelry (tiaras galore, honey!), gloves,
makeup, sexy skirts, and tiny tops than anywhere else in SF—not to
mention their handmade sequined pasties, flamboyant feathered caps,
and custom cowboy hats. Round 'em up, partner—this place is a must
for anyone visiting Haight Street with fantasy in mind.

—Margot Merrill

"Sex is part of **nature,**
and I go **along** with nature."
— MARILYN MONROE

Sugarpuss

Pour some sugar on me kitty!

248 Fillmore St. (at Haight St.), San Francisco; (415) 861-PUSS.
Open Tues–Sat: noon–7 p.m.

If you want to hit the clubs in style, your first stop on the hoochie mama express should be Sugarpuss. Opened in the summer of 2001 by ex-dancer Jen Summers, Sugarpuss offers a small but well-chosen selection of street wear, lingerie, and accessories from all over the U.S. for the sassy temptress in you. You'll find fantastic see-through mesh tops, vinyl pants, and cool shoulder bags by some of the best names in street wear like Porn Star Clothing, Lip Service, and Fine. The sale rack is on fire here, and the lower Haight crowd eats up the slutty clothing like it's the last hit in the bong. Break up with your boyfriend and get something revealing—you're sure to get laid wearing something from Sugarpuss.

—CA

Contents

50 **Perverted Publishers**

53 **Raunchy Reference**

53 Craigslist.com: Get Lain in Minutes—Or Not,
by Janelle Brown

55 **Sexy Shopping Sites**

56 Deep Inside San Francisco's Repository of Porn,,
by Jack Boulware

58 **Escorts**

59 More Bang for Your Buck: How To Get the Most
Out of Your Escort, by Nick LeBon

62 Whores and Hoodlums of Yore: The Barbary Coast,
by Lisa Montanarelli

63 **Fetish and BDSM Sites**

67 The Rise of the San Francisco Streetwalker,
by Carol Leigh, a.k.a. Scarlot Harlot

GETTING IT ON(LINE)
Sexy Sites

San Franciscans love to get dirty online. From innovative and kinky online communities to bizarre worlds of fetish, we lead the nation in adapting this new technology to more carnal uses. Seemingly everyone here is wired, from broke art school students looking to get laid through scandalous postings on Craigslist.com to the high-end executives cruising $400 escorts online to shy kinksters shopping for fur handcuffs and latex harnesses from the privacy of home.

The sexy world of erotica has also turned to the Internet. From cherished small houses producing series on S/M to big time distributors of the best erotic photography books in the world, San Francisco has a flourishing community of publishers who cater to a ravenous local book purchasing community.

So get ready for a wild tour of literate sleaze and lecherous fun on San Francisco's most salacious web sites.

P U B L I S H E R S

Sites/Pubs

Black Books

Sex geeks need apply.

www.queernet.org/blackbooks

Owned and operated by San Francisco writer/publisher Bill Brent, Black Books is more than just a publishing company. There's Black Books, the book publishing company; but there's also *Black Sheets*, the erotic magazine; *Black Book*, the guide for smut and wannabe smut writers; *Perverts Put Out*, the (almost) monthly reading series of San Francisco's erotic literary luminaries; and Black Sheets, the private pansexual parties. This octopus of a company has an arm in almost everything dirty in SF. The staff is knowledgeable and friendly, so if you're interested in the literate San Francisco erotica scene, they can help.

—CB

Cleis Press

Because Radical is Sexy.

www.cleispress.com

How long does it take to become a San Francisco institution? Cleis Press is well on its way. Founded 25 years ago by two literate lesbians, Frederique Delacoste and Felice Newman, Cleis began as a woman's press and a labor of love—and Delacoste and Newman still run the company with the same passion and care. From its first release, Cleis has always been groundbreaking: publishing radical authors such as Patrick Califia-Rice, Susie Bright, Carol Queen, Tristan Taormino, and Thomas Roche among others. No longer just a woman's press, Cleis now publishes titles such as The Ultimate Guide to Anal Sex for Men, Best Gay Erotica, and Best Bisexual Women's Erotica.

—CB

Greenery Press

Pioneers of S/M porn literature.

www.greenerypress.com

Greenery title S/M 101 opened the door for many wannabe leather daddies, masters, and slaves. The company is owned and run by Janet Hardy, who not only writes many of the titles, but also lives the lifestyle.

A polyamorous pervert herself, Janet shares the writing with two of her lovers: Jay Wiseman and Dossie Easton. If you want to get your rope skills in tune, your bondage knowledge above average, and find a way to tell your parents you're not just queer, you're kinky too, who better to tell you how then authors who have actually been there? Greenery publishes much more than the usual S/M tomes, but even if they didn't, this press would still stand alone as making a positive contribution for everyone who isn't just vanilla.

—CB

Last Gasp Publishing

The treasure trove of arty sex books.

www.lastgasp.com

Since April Fool's Day 1970, San Francisco-based Last Gasp has been publishing and distributing a very eclectic assortment of adult comics, books, and magazines. Today they offer a dizzying collection of independent and avant-garde adult titles of the highest caliber. From gorgeous coffee table books on fetish fashion by the biggest names in the biz to erotic titles straight from Japan, Last Gasp probably has that book or comic you can't find anywhere else.

—Mike Ferro

On Our Backs

The hottest porn magazine for chick-loving chicks.

www.onourbacksmag.com

The first incarnation of *On Our Backs* changed the face of lesbian sex; it was the first publication to feature hardcore lesbian porn. Lesbian and bisexual women who remember the original probably get wet just thinking about it. The infamous mag took a hiatus but now it's back just as hot, sexy, and informative. Each bi-monthly issue drips with racy girl-on-girl centerfolds, steamy smut, interviews with celebrity dykes, and true adventures from some of the best lesbian writers around. Where else can you get sex advice from porn megastar Nina Hartley? If you need something to do while the boss has her back turned, order the free e-newsletter to keep you satisfied between print issues.

—Lisa Montanarelli

Sites/Pubs

Spectator Magazine

The erotic voice of San Francisco.

www.spectator.net

This San Francisco sex staple (in business for over 25 years) comes in both a print and online version. It's jam packed with quality listings for Bay Area escorts, dominatrixes, and transsexuals; sexually explicit content; porn star interviews; and sex news and commentary. The comprehensive event listings are all you need to keep up with everything and anything sex-related in San Francisco. Articles and reviews are written by local sex authors, most of them well known and all of them talented. One can safely say that the *Spectator* is one magazine that has something for everyone. The paper might look cheap, but the mag's quality is high. Look for it at strip clubs, newspaper stands outside BART stations, and bus stops.

—CB

SFredbook.com

Revenge of the Johns...

www.sfredbook.com

While Craigslist.com gets all the virtual community kudos in San Francisco and beyond, sfredbook.com is an equally vibrant online community for the kinkier side of the city. It's free to use and allows users to anonymously view and post opinions on SF massage parlors, streetwalkers, strip club workers, and more. The threads here are lively and sometimes very specific. If you are looking for info on a certain escort (is she a rip-off artist or good at her job?), specific massage parlor worker, or even (surprisingly) SF streetwalkers who work in the Mission, some crazy John will offer you his two cents—usually within minutes. There is also a review database with over 14,000 reviews of girls and clubs that is open to VIP members who pay a yearly fee. This is a uniquely informative and entertaining web site that is San Francisco to the bone. The strip club section of the site is especially entertaining because girls who actually work in the clubs post anonymously—often setting the record straight on what really goes on behind closed doors in some of SF's most famous clubs. For up-to-the minute price information and the proverbial lowdown on sex in SF, sfredbook.com is the place to visit.

—CA

Craigslist.com
Get Laid in Minutes—Or Not

When San Francisco's horny hordes get desperate, there is only one thing to do: log on to Craigslist. Craigslist is a bona fide local institution, a hugely popular online community where you can find a job, sell your motorcycle, peruse upcoming events, and—you guessed it—get laid.

Craigslist's "Missed Connections" and "Casual Encounters" are much like the personals ads you might find in the back of your local alternative weekly. The former is for the lovelorn trying to find the cute girl they spied on the bus; the latter is for the lecherous looking to get down with an anonymous somebody—but with a twist. Not only are the uncensored posts of unlimited scope and length, but there are a lot more of them (some 742 Casual Encounters are posted every day) and they are, for the most part, both graphic and pathetically optimistic.

The Missed Connections section is filled mostly with your typical fruitless "I saw you on an airplane last Sunday and thought you were hot. Want to meet for coffee?" Few surprises, except the astounding fact that some 290 people post every day in search of the attractive someone they glimpsed but didn't have the guts to talk to.

It's the Casual Encounters, however, that are the fascinating read; particularly those posted in the wee hours of the morning by over-sexed locals hoping against hope that someone might find their ad within minutes and show up on their doorstep. To wit: "Hot white boy would do almost anything for a nice BJ right now!!!"

Other posts range from the reprehensible ("My girlfriend is gone for a week. My plan: Find some hottie that wants to hang out, smoke, drink, and screw all weekend. Any takers?"), the truly odd ("Ever since I was a kid I've wanted to stuff a chick's ass with Bologna. Is this weird? I am really hoping to do this on a Friday if at all possible."), and a whole lot of the "yeah, right" variety ("All escorts or dancers that need somewhere to kickback: Just seeing if there are any fun females interested in partying etc. or need a place to chill after they dance or strip.")

So, does anyone ever respond to these ads? Marcia Estarija, community director of Craigslist, shrugs. "Sometimes we'll get an email from someone telling us that they've found their missed connection or they'll actually post their success story on the site, but that isn't too often." Still, it doesn't hurt to hope, right?

—Janelle Brown

Exotic Dancers Alliance

Support your local stripper!

www.eda-sf.org

San Francisco is teeming with fabulous exotic dancers, but most of them work under less-than-fabulous conditions. Most clubs refuse to pay dancers minimum wage and require that the dancers pay "stage fees." The Exotic Dancers Alliance, founded in 1993 by Dawn Passar and Johanna Breyer, supports all sex industry workers by providing information, referrals, and advocacy services. Check out EDA-sf.org for EDA programs, legal resources, the laws that every stripper needs to know, and many other features (including animated dancing girls). Dancers interested in networking with other dancers can join an online newsgroup. If you're a customer, think back to the last time you got a lap dance. Did you pay the dancer directly, or did you have to buy a "dance ticket" from the club? Even if you put money in the dancer's hand, chances are she had to turn most of it over to the club as a "stage fee." Wouldn't you rather give your money to the beautiful girl who danced on your lap?

—Lisa Monanterelli

San Francisco Sex Information (SFSI)

Everything you ever wanted to know about sex and weren't afraid to ask.

www.sfsi.org

SFSI is a free information and referral switchboard providing anonymous, accurate, and non-judgmental information about sex in San Francisco. If they can't answer your question they'll find someone who can. You can give them a call with your inquiry during the hours posted on their web site, or, if you get flustered, send them an email. It may take a few days for them to respond, but if your question isn't urgent this may feel more private. SFSI volunteers undergo extensive training in all aspects of human sexuality, from reproduction and birth control, safer sex practices, HIV, and issues revolving around sexual and gender identity. SFSI is not a phone sex service, so if you're looking for something to wank to, this isn't the number for you.

—CB

Sites/Pubs

Blowfish.com

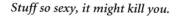

Stuff so sexy, it might kill you.

www.blowfish.com

This San Francisco-based online business features many of the same erotic products and toys that stores like Good Vibrations (see p. 27) carry. Ordering is easy and the reviews are helpful and well-written. The one problem is that they don't explain what each of their "blowfish" symbols mean. The site is also connected to fishnetmag.com, the magazine of Blowfish. Too bad a lot of the content hasn't been updated since 1997.

—CB

Bluedoor.com

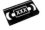

Every adult movie imaginable delivered to your door.

www.bluedoor.com

Santa Clara-based Bluedoor.com is emerging as *the* online superstore for pornophiles. Every straight, gay, and fetish adult video and DVD, from Snoop Dogg's *Doggystyle* to the infamous Tom and Pammy video to Heidi Fleiss' *Sex Tips With Heidi Fleiss and Victoria Sellers*, is up for rent at Bluedoor.com. The site is easy to navigate and database-driven so it's easy to search by porn star, director, title, or producer. If you prefer browsing hardcore XXX titles from the comfort of your own home, bluedoor.com is a well-designed, professional site that never fails to get your videos and DVDs to you within days (they rent nationwide) in a nice, discreet package. Videos and DVDs are also frequently on sale at bluedoor.com.

—CA

"Whether a long one or a thick one it matters not, as long as it satisfies in abundance."

— ISLAMIC PROVERB

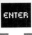

Sites/Pubs

Deep Inside San Francisco's Repository of Porn

"The clip we're about to see is from a film called *Make Mine Milk*,"says Paul Potocky, film archivist at the San Francisco Institute for the Advanced Study of Human Sexuality. "The gal who stars in it is lactating. It's one of my favorites, filmed right here in San Francisco." Potocky, who spends every day watching old porn films, taking notes on their condition, and transferring them to videotape, pushes Play on a VCR. The audience is treated to a grainy five-foot image of hippies having sex. However, we aren't sitting in a sticky-floor theater with peeling wallpaper. We are gathered in a meeting room at San Francisco's Cathedral Hill hotel for the 25th-anniversary gala weekend of a state-accredited institution of higher learning. And we've just had lunch.

For the next two hours, we watch clips from such classics as *Starship Eros*, *Hitler's Harlot*, and *The Rites of Uranus*. This last gem features a circle of guys in satanic robes chanting "Hail to your anus" to a gyrating woman, who sports a lit candle sticking out of her rear.

All of these fine flicks, examples from the dawn of America's adult-film industry, are the property of the institute. Earlier this year, San Francisco State University gained publicity for becoming the first state college in the western United States to offer a master's degree in human sexuality.

The institute is actually the world's largest repository of porn and erotica: three million items, including 400,000 films filling 22 warehouses throughout Northern California. We walk down a hallway garnished with colored drawings of wild sexual scenarios: a cartoon of a doctor sneaking pills to a naked female patient, a commedia dell'arte clown engaging in cunnilingus, and a woman tied up and getting spanked.

Next, Potocky ushers me into the video room, which has walls and walls of Beta and VHS tapes. And what might the students be studying? *Edward Penishands*. *The Dirty Debutantes* series. *Evolutionary Masturbation*. Potocky introduces me to librarian Jerry Zientara, who is reviewing a pile of postcards depicting muscled nude men. Zientara possesses the openness of someone who's seen every conceivable type of erotica. Whatever donations come through the door—films, books, videos, periodicals, pop-culture ephemera—he appraises their value and then catalogs them. I ask Zientara if he can still be shocked.

"Disgusted, but never shocked" he replies.

—Jack Boulware

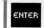
Sites/Pubs

Gamelink.com

The Costco of porn.

www.gamelink.com

Selective they are not; overwhelming they are. This massive site meets all of your sex needs and offers videos, CD-ROMs, DVDs, toys, leather, and erotic cards. You can choose between the straight mall, the gay mall, or the discount shopper's club. Anything and everything you need is here, but the coolest offering is video on demand. You can download porn movies right to your computer; all you need is a high speed Internet connection and a credit card. The colors are garish but the product is there. What else are you going to do at work besides discreetly download porn? Just remember to turn the sound on your computer off.

—Kelly Lewis

Sex.com

The sad story of the million dollar domain name.

www.sex.com

Perhaps no domain name back in the "dot-con" era of San Francisco attracted as much attention as that of sex.com in the media. Stephan Michael Cohen made millions squatting on sex.com illegally in the late 1990s. But in the highly publicized domain name squatting case, a judge recently ordered him to pay $65 million to the site's current and rightful owners. Naturally, Cohen (according to court documents) claims he is penniless and doesn't even have enough money to pay for toilet paper. The site today (a Yahoo-esque porn search directory) still generates huge traffic—as typing sex.com on their first computer is no doubt a current rite of passage for every 13-year-old boy in the world. The current owners are still awaiting their $65 million dollar check.

—CA

"How **many husbands** have I had—
you mean, apart from **my own?**"
— Z S A Z S A G A B O R

Xandria.com

The department store of sex toys.

www.xandria.com

Now's your chance to find out if bigger really is better. Based just south of San Francisco, Xandria.com is the largest local online sex toy store. Every bit as sophisticated as Good Vibrations (see p. xxx) and Blowfish.com (see p. xxx), Xandria.com is clean and easy to navigate. Xandria offers the usual dildos, dolls, and such, but unlike other stores, the site also offers sex education, a sex newsletter, a very helpful sex toy glossary, stories, jokes, and more.

—CB

Eros Guide

The best of the bay.

www.eros-guide.com

East Bay-based Eros Guide is without a doubt the best local escort directory. Voted "best erotic web site" four years in a row by the *San Francisco Bay Guardian*, Eros Guide will impress you with hundreds of young, gorgeous escorts. The site is impressively sleek, fast, and to the point. Eros Guide is available in over 30 U.S. cities as well as London—so they can now find you a good time in a wealth of places. Browsing Eros Guide is a fantastic way to see just how varied, open, and gorgeous the women of San Francisco and the East Bay truly are.

—Dave Williams

"I regret to say that we of the FBI are powerless to act in cases of oral-genital intimacy, unless it has in some way obstructed interstate commerce."

— J. EDGAR HOOVER

More Bang for Your Buck
How To Get the Most Out of Your Escort

Getting an escort in SF is a lot like going to the movies. The preview looked great, the excitement is exquisite, then the movie starts and you immediately want your $8.50 back. Thousands of San Francisco ladies promise the moon in their ads. However, the reality is that some of these women are professional con artists. You may end up paying $300 or more on a really bad private striptease with a "no touching" rule in effect if you don't do your homework. Here are a few tips and tricks to avoid a "disappointing film experience."

• **A picture is not worth a thousand words.** While many of the pictures of the escorts look great, don't count on the woman you get actually being the one pictured in the ad. Make sure to ask the agency (or the girl directly) if your date is in fact the one in the ad. Often it is advisable to look girls up on the Internet if you really want to make sure you are getting a specific escort.

• **Make sure to get the price up front and assurance that what you're asking for is covered in that amount.** Ask if the escort is "full service" or not. "Full service" usually means sex, or at least consensual touching, if that's what you're looking for. More than one escort has been known to arrive at a hotel room, then act confused/surprised/naïve when it comes down to what she's actually there for.

• **Know the way out.** If you get cold feet when the escort arrives, or if the girl is not to your liking, you can send her back. Make up an excuse (you have a meeting) and call back the service while the girl is there. Usually, for cab fare ($20–$40) they will send you another girl or call it even.

It is possible to enjoy a good blockbuster film from time to time, and it is also possible to hook up with a good escort in SF. Try to actually get the girl on the phone before she comes over to find out what kind of person she is. A little intuition goes a long way in finding that special someone for your pleasure.

—Nick LeBon

"Yes, there will be **sex** after death;
we just won't be able to **feel it.**"

— LILY TOMLIN

Sites/Pubs

Fog City Pleasures

Brighten up your day with one of San Francisco's hottest escorts.

www.fogcitypleasures.com

If you're taking a peek at this site at work, skip the flash intro or the sultry voice inviting you into a world of pleasure may attract some unwanted attention. The photos are really hot, and if the girls actually look like that, then these people should be millionaires. The problem is you can't really see the girls from the posted photos; many of the pictures are angled so the face behind the ass is hidden by the hair or cut out of the frame. The site does feature a few men and even offers adult film stars, listing when and where they are appearing and how to contact them. The site is simple and easy to navigate—but you might not always know what you're getting. Their phone lines are open 24 hours and you can book an appointment online, however they give no indication of how long it takes for the escort to arrive. Despite the somewhat foggy nature of this site, some of San Francisco's hottest (if not most expensive) escorts can be found at fogcity-pleasures.com.

—Kelly Lewis

Frugaljohn.com

Quality babes for the budget-minded.

www.frugaljohn.com

God bless escorts. Nice college girls who refuse to wait tables, preferring to utilize other talents to pay their tuition. Trouble is many of these ladies can exact a lofty sum, eliminating some of us poor slobs from the service pool. That's where Frugaljohn.com, based just south of San Francisco, comes in handy. Frugal John claims to be "Where cheap bastards find quality ladies," and there are certainly some luscious lasses on their site (though it would be cool to see their faces). It sure beats the hell out of a trip to Spearmint Rhino, at about the same price.

—Steve Robles

"Sex on television can't hurt you unless you fall off." — ANONYMOUS

Lovings.com

Millions served!

www.lovings.com

Lovings.com has logged over 32 million hits since it opened for business in January of 1997. Chances are, most of those pervs left satisfied, because this is one of the biggest and best escort directories in San Francisco. Bob Miller and his partner have ensured that the site loads fast and that visitors can see and contact the myriad world of bay area escorts, sensual massage therapists, and on-call masters of tantra. There is also a tiny magazine called *Inside Bay* on the site that has a few articles on sex in the bay area, but this site is mainly a straight-up adult escort listing service.

—Dave Williams

"Masturbation: the **primary** sexual activity of mankind. In the nineteenth century, it was a **disease**; in the twentieth, it's a **cure.**" — THOMAS SZASZ

Sexy and Foxy

Starfish and coffee, maple syrup and jam.

www.sexynfoxy.com

If you're looking for something more exotic than the typical blonde bombshell, then this site is for you; they feature a wide variety of girls in every ethnicity, size, and shape. They also feature bisexual couples to help you explore everything from tantric dance to voyeurism to group sex. The VIP page wasn't up when I visited but the main page has plenty of escorts to choose from and includes biographies, personal statements, and photographs. The prices are about average, although some are more affordable than others. This isn't the best site in San Francisco, but at least it's honest.

—Michelle Parsons

Sites/Pubs

Whores and Hoodlums of Yore
The Barbary Coast

Hankering for some shady San Francisco history? Visit the remains of the Barbary Coast—the nation's most notorious red light district in the late 1800s. As "miner '49ers" flooded into San Francisco for gold, whores worldwide set sail for the all-male boomtown by the Bay. The heart of the Barbary Coast rose on the blocks now known as Jackson Square Historic District, bounded by Washington, Columbus, Pacific, and Sansome Streets. These same few blocks boast the only cluster of commercial buildings that survived the 1906 fire and date back to the Gold Rush. In its heyday, the Barbary Coast covered 35 blocks between Stockton, Kearny, Broadway, and Market. Virtually every building housed a brothel or bar where "pretty waiter girls" sold drinks and sexual services.

In the 1880s, the pie-shaped block was called Devil's Acre, and the east side of Kearny, known as Battle Row, witnessed one murder a week and five brawls a day. Topless harlots leaned out the windows of small cubicles or "cribs," soliciting 10 cents to touch one breast, 15 for two, and anywhere from a quarter to one dollar to join them inside. Elegant French parlor houses, catering to a variety of sexual tastes, lined Commercial Street from Kearny to Grant. The building at 742 Commercial Street once housed Madame Marcelle's Parisian Mansion, and the Chinese Madame Ah Toy maintained two houses at 34 and 56 Pike Street (now Waverly Place).

Although the 1906 fire leveled most of the Barbary Coast, the underworld haven reemerged from the ashes, becoming a tourist mecca for middle class youth. Every establishment charged exorbitant prices and geared their shows to shock sightseers without scaring them away. Between 1906 and 1917, brothels and dancehalls lined the entire 500 block of Pacific (except for the firehouse at 515). Some of the buildings are still standing today: the Little Fox Theater at 535 Pacific, the Thalia at 544-550 Pacific, the Hippodrome at 555 Pacific, and 574 Pacific, the site of "Dash," a club that featured female impersonators. Dash closed in 1908 and was replaced by Purcell's, the most famous African-American dancehall on the Barbary Coast.

On February 14, 1917, police raided the Barbary Coast, closing 83 brothels and throwing more than a thousand women out on the streets.

—Lisa Montanarelli

Sites/Pubs

Darkplay.net

Goths gone wild!

www.darkplay.com

These are not your average, mall-going, poseur Goths who just discovered Siouxie. No, the fine folks behind darkplay.net are the real deal. Hard-body, lesbian Goth-punks engage in body modification, head shaving, "cuntsplicing" (don't ask), and more at this San Francisco-based site. The site is broken up into three deviant areas: Fetish, BDSM, and XXX. Check out the cool ultra-evil photo stories shot in Golden Gate Park with some seriously naked and kinky knife play and fake-blood drinking.

—CA

"Woman's **virtue** is
man's **greatest** invention."
— C O R N E L I A O T I S S K I N N E R

Fuckingmachines.com

The machines that take a licking and keep on ticking!

www.fuckingmachines.com

Over the last few years, this San Francisco-based site has been causing something of a sensation in porn and fetish communities worldwide. Featuring brave SF- and LA-based models and amateurs, fuckingmachines.com allows you to stream girls getting done by strangely mechanized dildo-esque contraptions with names like "The Goat-Milker" and "The Double Crane." Curious? You should be—you have never seen contraptions that one-up the vibrator like these before, and the girls seem to genuinely get into these unique machines that never roll over in bed. Over 10 models a week drop by the studio of fuckingmachines.com for "sessions," and these are listed on the site by time and model. Robotic sex has finally arrived in San Francisco! Men, your days are numbered.

—CA

Ouchy the Clown

San Francisco's premier (OK, only) adult clown.

www.ouchytheclown.com

Few clowns are as beloved as Ouchy in San Francisco. That's because Ouchy doesn't want to pathetically twist balloon animals for your kids, he wants to whip you—hard. Not only does Ouchy proudly offer pro-Dom services, he will also kindly help "facilitate" your next meeting or corporate event. Although Ouchy maintains a solid job working for a nonprofit by day, at night he becomes downright scary. So if you've got the cash, Ouchy has the time to make you laugh and/or terrify you and your kids. Just don't ask him if he has a drinking problem.

—CA

SFGoth.com

Black planet, black world.

Hard-core denizens of the night stay current on the San Francisco Goth and industrial community, SFGoth has the irreplaceable guide for visiting Goths entitled *San Francisco: An Idiosyncratic Guide for the Goth-Freak-Hipster-Nerd.* It includes such helpful observations as "Don't go to Fisherman's Wharf" and "Golden Gate Bridge is not in Golden Gate Park," not to mention the genuinely useful "How to get from the Haight to the Castro" and "How to get from SOMA to Noe Valley." You can also check out club listings which include most of the fetish-oriented events like the monthly party "Bound." The concert listings let you know who's coming to town, and for those who are dead set on overdosing on Bay Area Goth culture, you can join SFGoth. Zip up that black leather straitjacket, put the Sisters of Mercy on the MP3 player, and hop a flight. SF is the land of the dead, baby.

—Thomas Roche

"I went to a **meeting** for premature ejaculators. I left **early**."

– R E D B U T T O N S

SFSirens.com

Bow down and kiss the one you serve.

www.sfsirens.com

The San Francisco Sirens are the hottest, meanest, most tantalizing group of Dommes in the Bay Area and possibly the country. These women are gorgeous and judging from their web site they believe in ultimate female supremacy and total domination over men. They provide everything from spankings, foot worship, bondage, role play, corporal discipline, humiliation, hypnosis, female submission, sadism, fetish wear, and crossdressing. Goddess Athena, who runs the site, tells us that we "will find no comfort in her eyes." You will, however, find comfort in her beauty, which she uses to subjugate even the strongest of men. Janus, the other woman prominently featured on the site, is an experienced switch—you can watch this beauty suffer at the cruel hands of Athena. Just reading the site got me off! Even if BDSM isn't your thing, check this site out—you just may change your mind!

—Kelly Lewis

"One half of the world cannot understand the pleasures of the other."
— J A N E A U S T E N

Stitch Bitch

Costumes for the not-so-faint of heart.

www.stitchbitch.com

The site might be simple but the fashions are not. Lisa Peters has worked in costuming for over 10 years, including a stint with Universal Studios (yes, she can make you a slinky, sexy Catwoman outfit just like Michelle Pfeiffer's). She also made what I think is the coolest thing ever—the Alice in Wonderland costume that was worn to the Electronic Arts launch party for their twisted video game version of Alice in Wonderland. Stitch Bitch also does wedding dresses for that special day in every pervert's life.

—CB

In THE Buff

Two Knotty Boys

You're not going anywhere, bitch!

www.knottyboys.com

Two Knotty Boys (JD and Dan) offer professional rope bondage instruction in a variety of settings around San Francisco. Private instruction, group classes, and even live web-cam classes are offered (just in case you're too tied-up to make it or prefer complete privacy). With these hands-on classes, you're sure to walk away with skills you can use. Classes include sensual basic bondage, dominance bondage, sex bondage, decorative bondage, and suspension bondage (not recommended for novices). The boys also perform live demonstrations at various clubs in the city and offer professional bondage rigging for fetish photo shoots.

—CB

The Rise of the San Francisco Streetwalker

In 1848, there were approximately 200 prostitutes in San Francisco. A short two years later, 2,000 women arrived from Europe, New York, and New Orleans. Many of these ladies were prostitutes looking to benefit from the thousands of men that the Gold Rush drew to the city.

The Alta California newspaper announced the new arrivals of prostitutes daily. Madams and prostitutes took an active part in social life and their activities were documented as a sort of society page in San Francisco's heady gold rush days.

By the 1870s, San Francisco had a red light district bounded by Kearny, Stockton, Broadway, and Market Streets. In 1890, however, the Board of Supervisors began to pass a series of laws to drive prostitutes out and make way for the expansion of downtown. Within 10 years, the district was considerably smaller, but still operational. Streetwalkers were unusual because houses of prostitution, with the aid of bribes to city officials, were the general practice.

In the early 20th century, external pressure to curb prostitution became intense. In 1913, at the urging of women's groups and religious anti-vice crusaders, the state legislature enacted a Red Light Abatement Act. The law forced the closing of property used for prostitution.

On the night of February 14, 1917, 83 brothels were closed and 1,073 women were put on the street. As critics predicted, brothels were dispersed throughout the city and streetwalkers became more prominent.

—Carol Leigh a.k.a. Scarlot Harlot

Contents

70 Nude Beaches

71 Sex in the Streets: San Francisco's Street Fairs,
 by Jan Holder

72 Still Sexy After All These Years: The Exotic Erotic Ball,
 by Dave Patrick

76 Swing It, Sister: The Great Husband Swap,
 by Dara Lynne Dahl

78 Spa/Massage: Rub Me the Right Way

79 Undress for Success: Etiquette for Sex Clubs,
 by Lisa Montanarelli

TAKE YOUR CLOTHES OFF AND HAVE FUN
In THE Buff

San Francisco has always been a naked kind of town.
From Berkeley's infamous "naked guy" who strolled around the East Bay with no clothes and no sense of shame, to the numerous nude beaches that dot our beautiful coastline, you can shed your clothes (and your inhibitions!) quite easily in San Francisco.

The quickest way to get naked in the heart of the city is to pop into a massage parlor or spa. We list a few of the best, as there is simply not enough space in this book to list them all.

But really nothing is better (or cheaper) than heading out to one of the nude beaches. So grab that suntan lotion, rub it in ALL the right spots, and let *Horny?* be your guide to all things nude in the city by the bay!

In THE Buff

Keep in mind that while all these beaches have played host to public nudity for decades, not all of them are legally zoned as "clothing optional." The chances that you'd actually be arrested are next to nil, but take heed nonetheless—tickets are sometimes issued.

Baker Beach

Baker Beach has a long tradition of hassle free, clothing-optional recreation. The beach has a sliding scale of nudity: patrons are progressively less dressed the closer you get to the Golden Gate Bridge (nudity isn't allowed on the south half). Keep in mind that this is still San Francisco, and even though the weather is warmer than Ocean Beach, it is rarely a good idea to go outside without some degree of clothing. Your best bet for good weather is either September or October. And, being San Francisco, don't expect to see a lot of topless women at this beach.

To Baker Beach from San Francisco: Take Lincoln Boulevard south to Bowley Street and turn right. Take Bowley to Gibson Road and turn right to enter the Baker Beach parking lot. If you're on foot, take bus route #29.

—Alan Home

Bonny Doon

With a skinny-dipping tradition going back more than 30 years, this popular spot draws as many as a hundred visitors to the area at any one time. Protected from the wind by horseshoe-shaped cliffs to the north, the beach draws a wide demographic and is dog-friendly; the nude area is in the cove at the north end.

To Bonny Doon from San Francisco: Take Highway 1 south. Just past Davenport, turn right onto Bonny Doon Road, and park your vehicle in the unpaved parking area. Climb up the cliffs, cross over the train tracks, and you'll be overlooking the south end of the beach.

—Dave Patrick

Sex in the Streets
San Francisco's Street Fairs

San Francisco is notorious for hosting a street fair for every group, race, religion, and day of the week. Among these are the biggest public celebrations in the country featuring nudity, leather gear, and queers. Most fairs are free; some ask for a donation to a local charity, cause, or organization. Every fair has plenty of food and beer, but like almost everything else, there is a high price to pay (usually the next day) for indulging oneself.

San Francisco Pride Parade: Queers, bisexuals, transgenders, and straight people flock from all over the world to visit San Francisco's Pride Parade. The mecca of homosexuality in the United States, San Francisco boasts the biggest and the best in gay pride—the entire last weekend of June is full of activities, parties, readings, and (of course) lots of gay sex! Despite themes like "Queerific," SF is in no danger of losing the top slot for Gay Pride celebrations in the U.S. Check out www.sfpride.org.

Folsom Street Fair: If you're into leather, even just a little, you must be in San Francisco the last weekend of September for the largest leather street fair in the country. Live music, dancing (complete with nearly nude cage dancers), public spankings, free condoms, and thousands of men and women walking around nude, partially nude, in chaps, and even in full leather regalia (no matter the weather) are de rigueur at Folsom. Check www.folsomstreetfair.com.

Up Your Alley (or the Dore Street Festival): Though it's smaller than the Folsom Street Fair, the two are thematically similar. Up Your Alley, however, is attended mainly by native San Franciscans. Located in the famous Dore Street alley the last weekend of July, the fair largely draws a gay crowd, and the weather's warm enough for the boys to strip down to next to nothing.

Castro Street Fair: Gay, gay, gay. For those of you who don't know, the Castro is the gay neighborhood, and the Castro Street Fair is all about being gay. It has the usual arts and crafts booths, assorted food and beverage, plus lots of nearly naked men, outdoor dancing pavilions, and live music by bands that are 100% gay. The donations go to queer-related causes. Check www.castrostreetfair.org.

—Jan Holder

In THE Buff

Still Sexy After All These Years
The Exotic Erotic Ball

For over 20 years, the Exotic Erotic Ball has been one of San Francisco's wildest and most decadent parties. The first Ball was held on October 31, 1980, at California Hall on Polk Street. More than 1,200 partygoers filled the small venue where professional strippers took it all off on stage and free-spirited amateurs did the same on the dance floor. Local bands provided musical entertainment and the Mr. and Mrs. Halloween Contest awarded $250 in cash and prizes. The wildly salacious party filled the void created in 1979 when Margo St. James abandoned her Hooker's Ball after a popular but unprofitable six-year run.

As time went on, bashes became more and more spectacular, with the shows involving a bizarre collection of performance artists and circus performers that include fire eaters, belly dancers, contortionists, magicians, and gymnasts. Professional strippers, both male and female, competed in the Mr. and Ms. Exotic Erotic Contest, with $10,000 in cash and prizes awarded to the winners. Major league musicians began making appearances—Grace Jones, Sugar Ray, Joan Jett, Motörhead, Mickey Thomas, Chris Isaak, Gregg Allman, the Chambers Brothers, Edgar Winter, Primus, and Matt Zane's Society 1 have all played as Exotic Erotic headliners.

Sadly, founder Lou Abolafia died of a heart attack in Los Angeles on Halloween in 1995 without seeing his dream of coast-to-coast Exotic Erotic Balls come true. Although the Exotic Erotic tour has managed one-night stands in Miami and New York City, ultimate nationwide success still eludes Abolafia's surviving business partner Perry Mann.

Nevertheless, Lou would certainly be proud of Exotic Erotic's continued prosperity in San Francisco. The bash has been featured on HBO, the Playboy Channel, and broadcast live over the Internet. In 1998, the Ball moved once again to its current home at the Cow Palace, a cavernous three-hall facility with 50,000 square feet of floor space and a 15,000-person capacity. Thanks to a budget that allows for outrageous stage lighting and a fantastic sound system, the Exotic Erotic Ball is a world-class production that continues to knock the socks—and sometimes more—off it's devoted fans.

—Dave Patrick

The Exotic Erotic Ball is usually held on the Saturday before Halloween. Visit www.exoticeroticball.com for information and pictures.

Grey Whale Cove State Beach

Just south of San Francisco in San Mateo County is Grey Whale Cove State Beach, offering exquisite examples of Northern California's unique topology and natural geography. The sparkling shore is clean and wide, and the magnificent surrounding cliffs block the wind and make for interesting scenery along this piece of the California coast. Swimming isn't recommended due to strong tides and occasional great white shark sightings. Formerly a privately run nude beach called Devil's Slide, it was renamed last year when the State acquired it. There was some concern that free-spirited nudity would be eliminated, but community support prevailed and the beach remains nude-friendly. Although the signs designating the area clothing-optional were removed and a greater number of suited bathers are showing up, be assured that you may loose the clothes and run free along this expansive tract of sand!

To Devil's Slide from San Francisco: Take scenic Highway 1 south about 25 miles through Pacifica. Three miles south of the Denny's in Linda Mar, turn left on an unmarked road, which leads to the beach's parking lot. Cross the highway in the crosswalk, head down the gated driveway, and take the 146-step staircase to the beach. Landslides sometimes close the nearby area of Highway 1 during wet periods.

—Dave Patrick

Hagmire Pond

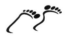

For devoted sun worshippers, there's nothing more frustrating than having a day at the beach ruined by coastal fog that refuses to burn off. That's when those in the know travel inland to Hagmire Pond, where the sun always seems to shine. Although the water is weed-clogged and rarely inviting—not to mention occasionally unhealthy to swim in—most folks just come here to bare it all, soak up some rays, and enjoy the lush, tree-lined setting.

To Hagmire Pond from San Francisco: Take the 101 Freeway north and exit at the Stinson Beach/Highway 1 exit. This turns into Shoreline Highway; stay to the left and keep going until you pass Dogtown. About a mile and a half further, you'll see cars parked along the road. Find a

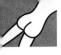

parking space, walk through the gate sign marked, "Fire Lane—Keep Clear," and follow the dirt path to the pond.

—Dave Patrick

Land's End Beach

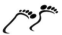

When you're in the city but itchin' to bare it all, head for scenic, rocky, quarter-mile-long Land's End. It's laced with sandy nooks and there are some flat rocks to stretch out on. Be sure to bring a sweatshirt or light jacket in case the wind picks up or fog blows in. Owned by the Golden Gate National Recreation Area, it's mostly a gay hangout, but still gets a diverse mix of visitors.

To Land's End from San Francisco: Take Geary Boulevard west to its end at 48th Street. Look for the Cliff House and park in the dirt lot just up the road. Take the trail at the end of the lot. After another 100 yards (past some trash cans), the path widens—head to the left. Just past another bench, as the trail turns right, go left toward a group of dead trees where you'll see a stairway with a "Dogs must be leashed" sign. Take the stairs to the end, then go left to another stairway which leads to a 100-foot walk to the cove.

—Gary Hanauer

"It is **impossible** to obtain a conviction for **sodomy** from an English jury. Half of them don't believe that it can **physically** be done, and the other half are **doing it**."
— WINSTON CHURCHILL

In THE Buff

Panther Beach

With a spectacular vista of towering cliffs and unusual rock formations accented by the frothy, explosive landings of incoming waves, this clothing-optional site is a favorite of those who prefer to get away from the crowds. To avoid possible injury or the embarrassment of landing on your ass, we recommend wearing hiking boots rather than flip-flops. For the best scenic views, pass through the natural hole in the cliffs and head south.

To Panther Beach from San Francisco: Take Highway 1 south. Just after Davenport start looking for a dirt road on your right between the highway and some railroad tracks. Be prepared to make a very sharp turn and park in the dirt lot. Follow a steep and somewhat eroded dirt path down to the beach.

—Dave Patrick

"I don't see much of **Alfred** since he got so interested in **sex**."
— M R S . A L F R E D K I N S E Y

Pomponio State Beach

A long, eroded path makes the journey to the small but scenic skinny-dipping cove at Pomponio somewhat hazardous. But on warm days a few naturists usually show up at the wind-protected, mile-and-a-half-long beach.

To Pomponio State Beach from San Francisco: Take Highway 1 south about 12 miles past Half Moon Bay. The nude area is at the south end of Pomponio; in low tide walk south along the water from the Pomponio entrance. Or from the old Pomponio turnout (marked with pole-like barriers) on Highway 1, follow the path down until it comes to a ravine with a stream. Forge across to the beach.

—Gary Hanauer

Swing It, Sister
The Great Partner Swap

There's nothing worse than arriving at a play party, libido and toy bag in tow, only to realize with growing dismay that everyone else there is (a) really overweight; (b) inordinately hairy; (c) has a large potbelly hiding a small weenie; (d) no one you'd share a drinking glass with let alone a French kiss; (e) reeking with B.O.; or (f) some heinous combination of a–e.

Fortunately, if the crowd at **Lush** is any indicator, Bay Area swingers have more in common with the term "hipster" than "wife-swapper." Lush seems to draw the most consistently attractive twenty- to fortysomething crowd in the city. Be prepared to shell out some cash if you want to hang out with the beautiful people—Lush is a member's only club. And don't think you can wear any old raggedy thing because you're just going to take it off. This upscale sex club has a strict dress code.

For those who believe experience counts, **Barry and Shell** have over 30 years of party practice. That's a hell of a lot of Saturday night suck 'n' fu…er, we mean erotic encounters. Every Saturday, couples and single women with reservations can "sexplore" three floors of themed, music-filled rooms. Mirrored ceilings, private nooks, an indoor hot tub, dance floor, porno films (for ambiance of course!), and an orgy room complete with glory holes round out the experience. There's even a buffet for those who are more hungry than horny.

For performance art and orgies, London-born latex couturier and event promoter Polly Pandemonium throws (at irregular intervals) **Rubbish**, SF's most interesting underground play party for pansexual perverts. This probably isn't the party for you if you're not at least one of the following: creative, wacky, a little narcissistic, über-hip (and people other than yourself share that opinion), really into fashion, or involved in some sort of fringe art or sex industry scene/occupation.

Maybe you're not hip to that "check your clothes at the door and get busy" sex party ambiance. **Pleasurezone 69** is swinging with training wheels. Produced by women for women and couples, it's where you go to loosen up with a few Cosmos, dress slutty, dance dirty, and cruise shamelessly. A bit more than a nightclub but not a swing party (no nudity or sex inside the club), it's all about the hotel after-party action.

—Dara Lynne Dahl

See next page for club digits.

The Club Digits:

Lush: (415) 923-1888; www.lush-sf.com. Open Sat: 9 p.m.–3 a.m.

Barry and Shell: (510) 834-5808; www.barryandshells.com. Open Sat: 8 p.m.–3 a.m.

Rubbish: (415) 789-8513; www.moralminority.com.

PleasureZone 69: at Club Decibel, 699 Market St., (at 3rd St.), San Francisco; (415) 789-7375; www.pleasurezone69.com. Open the fourth Sat of the month: 9 p.m.–2:30 a.m.; Couples $50; Single ladies $20.

Red Rock Beach

The Woodstock generation survives the new millennium here at Red Rock; it's a hippie's dream of peace and love come true. Drawing a mellow crowd of New Age types, tattoo fans, body-piercing devotees, aging rock stars, and counter-culture icons (including Wavy Gravy), Red Rock could only exist in a place like Marin County, the same notorious location where the hot tub was invented. As you might expect, the most popular activities are playing Ultimate Frisbee or hacky sack, nude rock climbing, snoozing in the sun, and discretely puffing a little you-know-what.

Also check out www.redrockbeach.com.

To Red Rock Beach from San Francisco: Take the 101 Freeway north and exit at the Stinson Beach/Highway 1 exit. This turns into Shoreline Highway; follow all signs towards Stinson Beach and stay to the left. You'll pass the turnoff for Muir Beach, and just after a gated turnoff for the Steep Ravine Environmental Campground, turn into the large dirt parking lot. Hike the quarter-mile path (watch for poison oak!) right to the beach.

—Dave Patrick

"A lady is one who never shows her underwear unintentionally."

— LILLIAN DAY

Blue Sky Massage

Let them rub your blues away.

738 Larkin St. (between O'Farrell St. and Ellis St.), San Francisco; (415) 441-7703. Open Daily: 10 a.m.–3 a.m.

Like Rice-A-Roni, this one's a San Francisco treat. Blue Sky girls represent nearly every Asian ethnicity (Japanese, Thai, Vietnamese, Filipino, Chinese, Korean) and the ladies are pleasant, very willing to satisfy, and often give the most professional massage you're likely to receive in these parts. There is a bath or shower in every room and, instead of massage beds, a mattress laid upon the floor (allowing the girl to get that much closer right off the bat). The only drawback? You don't choose your own girl. The one who answers the door is yours. But be polite, assertive, and graciously ask the designated hostess how many girls are working. She may quip back (in slightly broken English), "How many girls you need?" Just say, "Oh...you know...about six or seven." She'll probably laugh and bring the other girls up front. Let the exotic scent and heavenly bodies of Blue Sky carry you away to the intoxicating regions of the Far East.

—Anthony Petkovich

Empire Health Spa

The Empire strikes back!

428 O'Farrell St. (at Taylor St.), San Francisco; (415) 441-4133. Open Daily: 10 a.m.–3 a.m.

If you like girls from Hong Kong, Japan, Thailand, or Vietnam, Empire is the place to visit while in San Francisco. A stunning selection of girls work every night, but the best work on weekends. The girls wait in the entryway watching TV and giggling amongst themselves. The housemother will choose one for you unless you specify otherwise. Either way, you are bound to receive a fantastic massage at this busy downtown parlor. You may feel a bit pressured to take a shower before you see a girl, but don't worry if you must leave your belongings in the room. Empire is a reputable spa and no one here is out to rip you off.

—Dan Hullman

Undress for Success
Etiquette for Sex Clubs

When Emily Post said "polite society," she wasn't thinking of a sex club. But like other social venues, sex clubs have their own set of dos and don'ts. If you're new to the scene, it's wise to learn them, just as you would before visiting a foreign country.

• **Practice safer sex:** If you don't already practice safer sex, learn before you go to your first sex club, even if you are planning to have sex only with your fluid-bonded partner. Most sex clubs have their own rules, which they post or hand to guests at the door; many provide the necessary latex barriers, from condoms to Saran Wrap.

• **Dress for the occasion:** Don't wear street clothes. Depending on the club, you may choose to go naked, wrap a towel around your waist, or dress up in frilly lingerie or fetish wear. Some people like to bring several outfits or learn the club's customary garb in advance.

• **Ask before you touch:** A lot of people go to sex clubs because they like being watched. A group grope isn't necessarily a free for all. If they haven't invited you, keep a respectful distance and ask before you touch.

• **Set boundaries in advance:** If this is your first time at a sex club, you don't know how you'll respond to the environment. Decide what you will and will not do before you go.

• **Respect sexual and social space:** Most sex clubs designate a place for people to have sex and a separate place for people to talk and eat snacks. In the sex space you can negotiate sex, but don't disturb the people around you by making everyday chitchat. If you want to catch up with a friend, take your conversation to the social space.

• **Verbalize your desires:** Some people prefer not to talk during sex, but when you're new to sex parties, it's better to err on the side of caution. A yes or no answer sends a clearer message than a nod or shake of the head.

• **After you leave the club:** Don't assume the hottie you hooked up with at the club will want a repeat performance the next time you see her. If she seems uninterested, don't pester her and try not to take it too personally. Although some meet their soul mates at sex clubs, many come to these clubs for anonymous sex or a one-time experience.

—Lisa Montanarelli

In THE Buff

Hot Tubs on Van Ness

Where good friends and girls meet.

2200 Van Ness Ave. (at Broadway), San Francisco; (415) 441-8827. Open 24/7.

You would expect sleazy. You would at least expect the lobby to be dimly lit. You might even expect to walk out of one of the rooms with a little "love" on your shoe. But the conscientious staff is not going to let that happen here. After all, we're just blocks from the Marina on Broadway and Van Ness, not on Market Street. Not all the Hot Tubs clientiele are on "dates," but that does seem to make up most of their business. The rooms run $40 for two people and contain a hot tub, sauna, a little bed (cot with plastic mat on it), and a shower. They are actually quite nice and clean considering what goes on behind closed doors. The hour I sat in the lobby I saw many meetings occur and most couples seemed to know each other (although who knows how well). While it doesn't look like a good place to pick up someone new, it's a great place to take an established flame. Hot Tubs on Van Ness is the perfect set-up for businessmen who want to spend their lunch hour with the secretary doing something a bit more "extracurricular."

—CB

Nikki's Oriental Massage

I knew a girl named Nikki...

1172 Sutter St. (at Polk St.), San Francisco; (415) 771-0522. Open Daily: 10 a.m.–2 a.m.

There's rarely more than three girls working at any given time, but don't let that stop you from getting a massage here. In fact, the lack of business at this Asian parlor works in your favor if you want the most bang for your buck. Most of the girls who work here are Korean and all are quite pleasant. The second story space is cozy and the rooms are neat and clean. The music from the bar downstairs may bother you, but overall Nikki's is a great place to get an unhurried massage from a girl who will truly spend time with you.

—Dan Hullman

Palm Tree Massage

An oasis in San Francisco's concrete jungle.

12 Valencia St. (at Market St.), San Francisco; (415) 626-5438. Open
Daily: 10 a.m.–midnight.

Palm Tree is almost perfect. There are plenty of wall-to-wall Korean
dolls and, like most Korean-run places in the city, all the babes line up
for the customer's selection upon entry. The ladies (on average) are deli-
cious and range from age 18 to 40, though most are (damn it all!)
younger honeys. It's a very spacious parlor, the rooms are well-kept, and
all are equipped with showers, cozy massage beds, and sofa chairs—if
you want your massage while sitting on cloud-like pillows of imitation
leather. I've hit gold here, receiving truly outstanding, therapeutic mas-
sages from the most tantalizing tarts with absolutely amazing augmenta-
tions to their art.

—Anthony Petkovich

> "We have reason to **believe** that
> man first walked upright to free his
> **hands** for masturbation."
>
> — LILY TOMLIN

Sun Spa

More than the sun rises at this spa!

801 Geary St. (at Hyde St.), San Francisco; (415) 928-7938. Open
Daily: 10 a.m.–midnight.

A spa chock full of typically lovely, shapely Korean babes. Ages range
from the fresh 18 to 35. It's clean, comfy and every room has a roomy
shower and a relaxing massage bed with crisp sheets! And (big plus!)
upon the customer's entry, all of the chicks line up for your selection.
Marvelously sexist—eat your heart out, James Bond!

—Anthony Petkovich

Contents

84 Shopping in Fetish SF

84 Home is Where the Harness Is: Mr. S Leather and Fetters,
by Mistress Morgana

86 Sex Outside of San Francisco: In the East Bay,
by Cara Bruce

89 Fetish Clubs/Nightlife

89 Stranger in a Strange Land: S/M Shops for the Uninitiated,
by Mistress Morgana

90 The Geek Sex Underground: Whips and Chains in the
Silicon Valley, by Marci Stiener

93 Dungeons

93 Play Time!: At the Power Exchange,
by Kathy Sisson

94 Rules of the Dungeon: Don't Offend the Hardcore Perverts!,
by Midori

97 Change Your Tune: The Beauty of Porn-E-Okie,
by Charlie Amter

98 Pimping Ain't Easy: San Francisco's Legendary Fillmore Slim
Sings the Blues, by Charlie Amter

S&M, B&D, YOU & ME
THE Fetish Scene

Who has more pro-Dommes and dungeons than taxi cabs?
Who lists the Church of Satan under Religions in the Yellow Pages? San Francisco, of course!

The San Francisco fetish scene is the best in the country. From fairly tame weekly clubs to hardcore web sites, there are thousands of young, hot players in the underground fetish community. The only city that compares is New York, but the big apple's population is considerably larger and more stressed out! San Francisco was built on a model of acceptance—everything and anything goes, from the free-love hippies to the current leather set that lines up to give spankings for charity at the Folsom Street Fair.

Whether you're looking for leather, hot wax, some police-issue hand-cuffs, or a vinyl nurse's outfit, San Francisco has it. Home to some of the best latex and leather designers and manufacturers in the country, this is the place to get the best gear from some of the best-run shops catering specifically to the fetish community.

It doesn't matter if you're a seasoned switch or a nubile novice, whether you need a good flogging after laying off your dot-com employees or you simply want to learn how to safely tie your partner up, there is something for you in San Francisco's fetish scene. From classes on S/M 101 to fully equipped dungeons, from a public S/M sex club to very private one-on-one sessions from a seasoned pro-Domme—you can even walk around wearing just your leather chaps and none of the locals will bat an eye. The most beautiful city on earth has a thriving underbelly, and thankfully, more than enough people to help scratch it.

Home is Where the Harness Is
Mr. S Leather and Fetters

In my work with newcomers to the S/M scene, I offer guided shopping tours of San Francisco leather shops. My favorite place to take nervous newbies with a penchant for restraint is **Mr. S Leather and Fetters**. Established 20 years ago by Brit Alan Selby, Mr. S has expanded from its humble beginnings to support three stores and an international mail order and online business. The company is renowned as a source of high-quality leather bondage gear and fetish clothing, with an emphasis on original design, custom work, and customer service. Of course, the store's sterling reputation and commitment to quality may be overshadowed by the giant steel cage, leather body bags, and suspension-equipped straight jackets on display by the front door. But the scary stuff is what Mr. S does best. Add this to the fact that the shop caters to a gay male clientele, and you've got enough taboos to keep middle America far, far away from the nipple clamps. Which is exactly why I encourage people to visit Mr. S.

The heart of the Mr. S design team consists of scene players who bring their own passions to the workbench and personally test each design. As a true leather fetishist, my hands itch to touch and admire the intricately designed items suspended from the walls or laid out around the store. But if you get nervous, close your eyes and inhale the scent of leather that permeates the store. And just like that, all the initial scariness of miles of black leather and heavy chains melt into a warm, comforting fragrance of fine craftsmanship.

Also visit the newly opened Madame S, located directly across the street. Established in September 2001, this newest addition to the Mr. S family has taken its place as San Francisco's premiere women's fetish clothier. The in-house line of latex and leather fetish fashions for women feature fresh and creative designs and immaculate construction, and Madame S also offers restraints and toys in rich reds, blues, and greens: a nice departure from the basic black so predominant in fetish gear.

If your friendly neighborhood dominatrix is unavailable to escort you to Mr. S, don't despair. You'll be hard pressed to find a friendlier, less judgmental group of folks than those who staff the front counter. They will kindly walk you through every pair of nipple clamps and let you know exactly which cock ring is right for you with a smile, regardless of your gender, sexual orientation, or level of experience.

—Mistress Morgana

Mr. S Leather & Fetters USA: 310 Seventh St. (between Folsom St. and Harrison St.), San Francisco; (415) 863-7764 or (800) SHOP-MRS (746-7677); www.mr-s-leather.com. Open Mon–Sat: 11 a.m.–7 p.m., Sun: noon–6 p.m.

Dark Garden Unique Corsetry

The hippest fetish boutique in town.

321 Linden St. (at Gough St.), San Francisco; (877) 431-7684; www.darkgarden.com. Open Tues–Fri: 10 a.m.–6 p.m., Sat: 11 a.m.–5 p.m., Sun: noon–4 p.m.

Autumn Carey-Adamme's Dark Garden has slowly but surely won over just about everyone in the Bay Area Fetish community. Her custom-made fetish wear is expensive ($150 and up), but worth every penny. Dark Garden's talented staff will help you choose your own material (leather, satin, etc.), color, and style. Personal measurements are taken and an individual pattern is drafted. Patterns and measurements are kept on file for future reference. You can see a sampling of the gorgeous array of outfits designed by Dark Garden in their free catalog, at the store, on internationally known fetish supermodels, or in magazines like *Skin Two.*

—CA

Foot Worship

Do you have that in a size 14?

1214 Sutter St. (at Polk St.), San Francisco; (415) 921-FOOT; www.footworshipsf.com. Open Mon–Sat: 11 a.m.–7 p.m.

San Francisco is a shoe whore's dream. But what if you are a 6'5" cross-dresser with size 14 feet? No need to worry—Foot Worship has got you covered. This small store in the Polk Gulch district offers up thigh-high, lace-up boots and stiletto heels for all sizes. They custom-order brands to fit their eclectic female and increasingly male clientele. Billing itself as the "ultimate fetish footwear experience," Foot Worship goes out of its way to ensure that you can find shoes to match any outfit or occasion.

—CA

Fetish | SMBD

Sex Outside of San Francisco
In the East Bay

Few people outside the Bay Area consider the East Bay more than an extension of San Francisco—especially when it comes to sex. But the East Bay (primarily Berkeley and Oakland) has its own sex life. In fact, liberal attitudes were practically born in Berkeley, and wherever there's free thought and radical ideas, there's usually a great sex scene to boot.

The Kensington Ladies' Erotic Society is an East Bay staple. This group of proper, middle-aged ladies burst into the spotlight in 1984 with *Ladies Own Erotica*, a book that got the nation talking about the differences between male and female eroticism. Now, nearly two decades later, they are all over 60 years old and they're still pumping them out. Widely interviewed and wildly read, they prove that no one in the East Bay is innocent.

The East Bay Voice is an online paper and site for the gay and lesbian East Bay community. Yes, there are gay people outside of San Francisco. Their site covers events, entertainment, news, activism (a popular Berkeley hobby), employment, personals, and so much more.

A little different but way more interesting, are the **Punany Poets**. Founded by East Oakland native Jessica Holter a.k.a. Ghetto Girl Blue who single-handedly put spoken word on the East Bay map long before poetry slams were held regularly in every bar and coffee shop. The Punany Poets have always talked about things that were uncomfortable, mainly S-E-X. They've tackled the AIDS crisis in the black community, homosexuality in prisons, and every other sexual awareness issue under the sun. The Punany Poets have appeared on HBO's *Real Sex, Playboy TV*, and *BET* (Black Entertainment Television). Hey, when you have something important to say, people notice.

In the heart of Oakland's quaint Jack London Square lies the pervy **Xanadu Video**. Open 24/7, there is a constant stream of businessmen, tourists, students, and outright homeless men frequenting Xanadu Video. And they are not there to rent the movie with Olivia Newton John. Two adult theaters and over 30 arcades grace the spacious Xanadu Video. Your typical XXX fare play in both theaters and arcades. A word to the wise—there are several shadowy men lurking in the back arcade rooms. Make sure that door is locked TIGHT (unless you want a surprise from a not-so-straight man!).

—Cara Bruce

See next page for East Bay Digits.

The East Bay Digits:

East Bay Voice: www.eastbayvoice.org.

Punany Poets: www.ipunany.com.

Xanadu: 201 Broadway (at Second St.), Oakland; (510) 465-0374.

Image Leather

Image is everything.

2199 Market St. (at Sanchez St.), San Francisco; (415) 621-7551.
Open Mon–Sat: 9 a.m.–10 p.m., Sun: 11 a.m.–7 p.m.

Nestled on the edge of the Castro for nearly 20 years, Image Leather has provided a voyeuristically titillating experience for those enthralled by the process of leather crafting. For the past nine years, lead tailor Kevin Holbert has sat at his workbench in the shop's bright and sunny window and pounded away at chaps, belts, and bondage gear for all of Market Street to see. Like many Castro establishments, Image Leather caters to man-loving men, but the friendly and down-to-earth staff is happy to help folks of all genders and orientations. You'll find the essentials of any leatherman's wardrobe, including chaps, harnesses, vests, pants, jackets, hats, and boots—everything a boy needs for a night out on the town. Image Leather also produces an extensive line of leather cock restraints, bondage gear, and studded belts and wrist cuffs. Many patrons opt for custom fitting or alterations while getting their hair trimmed at the co-owned Male Image barbershop next door. How's that for full service?

—Mistress Morgana

Leather Etc.

You say you want leather?

1201 Folsom St. (at Eighth St.), San Francisco; (415) 864-7557;
www.leatheretc.com. Open Mon–Sat: 10 a.m.–7 p.m., Sun: 10 a.m.–5 p.m.

Just down the street from high-end BDSM boutiques like Stormy Leather and Madame S lives fetish wear's trashy cousin, Leather Etc. The staff isn't as hip and sexy as other stores, the changing room feels like a closet, and the store is packed with fetish wear and toys that vary greatly in quality, often bordering on novelty items rather than serious BDSM gear. But

don't let the cheesiness fool you—buried between the fishnet teddies and the poorly glued whips you might find a good PVC cat suit at a great price. On a recent trip we were able to find paddles, leather wrist and ankle restraints, collars, and leather cock rings. Not bad, but then we also found ourselves being ogled by the staff. In addition to fetish fashion and BDSM toys, Leather Etc. also stocks a full range of more "vanilla" leather jackets and pants for men and women.

—Mistress Morgana

Leather Masters

Masters and servants shop here.

969 Park Ave. (at Cleaves Ave.), San Jose; (408) 293-7660; www.leathermasters.com. Open Mon–Sat: noon–8 p.m.

This San Jose-based fetish wear and toy company has been in business since 1989 and supplies quality leather gear and toys to South Bay pervs of all genders and persuasions. A friendly, knowledgeable staff is on hand to offer advice and assistance without judgment, which is a good thing when you're feeling a bit shy about asking exactly which posture collar or cock ring is right for you. You'll find a wide assortment of leather paddles and whips, spreader bars and restraints, hoods, blindfolds, gags, electrical and medical equipment, dildos, butt plugs, men's and women's fetish clothing, as well as sound advice on how to use them! Leather Masters doesn't offer particularly refined, boutique-quality leather gear, but their stock is consistently high caliber. For those who aren't in the South Bay but are looking for a good catalog of general BDSM gear, their online and mail order catalogs make for great at-home shopping.

—Mistress Morgana

Moral Minority

Latex for all of us.

2519 Mission St. (at 21st St.), San Francisco; (415) 789-8513; www.moralminorityinc.com. Open by appointment only.

Polly Pandemonium is the visionary behind this world of latex. Hailing from London, Polly made her name designing high-end latex fetish fashions in Europe. Now, she's dressing San Francisco's sexiest fetish scen-

Stranger in a Strange Land:
S/M Shops for the Uninitiated

Tourists come for the cable car rides, the sourdough bread at Fisherman's Wharf, a windy walk across the Golden Gate Bridge, and the winding charm of Lombard Street, but millions of people also visit San Francisco for the city's reputation of tolerance and acceptance of different lifestyles. Whether you're visiting from Iowa or living in Nob Hill, you're bound to notice that many San Franciscans have a penchant for openness—and still others have a penchant for open-backed leather trousers.

With one of the oldest and most established Leather Communities in the country, San Francisco plays host to both the nation's largest public S/M event (the Folsom Street Fair held annually in late September) and a dazzling assortment of shops and boutiques dedicated to outfitting and equipping sexual fetishes and fantasies. People who engage in consensual S/M have devoted a lot of time and thought to their fantasies and their actions, often joining local organizations, attending classes, and reading books to better actualize their passions. Whether you're a local or a visitor, there is a proper etiquette to visiting fetish shops that will ensure you get your eyeful while respecting those around you.

• **Visit fetish shops with a sense of fun—but not to make fun.** The owners, staff and patrons of such shops are serious about their business and their lifestyles, and don't appreciate gawkers or social critics looking to pass judgment. If you want a good laugh, rent Exit to Eden. If you want to see how you look in a leather body harness, go shopping!

• **Many first-time visitors to fetish shops are nervous, just like you!** Experienced leatherfolk may feel like a kid in a candy store, but to the uninitiated, a fetish shop can look like a pretty frightening place! The staff, however, are probably kinksters themselves who can offer friendly expertise about the items they stock and will be happy to extend assistance to scared or tongue-tied customers. Just remember that you are a guest in another person's country: take a moment to learn the language and educate yourself in the culture and traditions, and approach new ideas with kindness.

• **Fetish shops are not nightclubs or singles bars.** Have fun browsing the cool toys and shopping for a divine outfit, but let other people do the same. It's rude and distracting to be approached in a fetish store. Go to explore your kinky side, not to pick up on your fellow shoppers or get your rocks off.

—Mistress Morgana

Fetish | SMBD

The Geek Sex Underground
Whips and Chains in Silicon Valley

Scratch a cultural phenomenon in the land of capitalism and you're bound to find money at its core. So when a thriving S/M scene arose in Silicon Valley, reasons probably included the high-tech, high-salaried occupations (enabling purchases of expensive PVC suits and ceiling harnesses) and the high levels of stress that make fetish and S/M the ideal weekend release. Odyssey, an organization devoted to the pursuit of BDSM, is what many computer industry geeks use to connect to a kinky and its elaborate S/M parties.

When I attended one of these Odyssey-sponsored parties, over 300 Silicon Valley scensters convened to tie each other up, whip behinds, and work themselves into an altered state. Yet the event smacked not of spanked butts but of conspicuous spending, and the only altered state appeared to be a bored state of undress.

The party was fancy and formal. Stretch limousines brought women clad in elaborate get-ups and men in tuxedoes. The decadent dress was offset by those who chose to go nude, save for strategically placed chains or leather.

In the play space, observers stood on the sidelines, their faces registering wistfulness or curiosity. In the lounge area, a crowd discussed real estate and the computer biz while munching on shrimp cocktails. No one was actually having sex.

My partner and I stepped into the main arena to play and were immediately accosted by a man in a tuxedo wearing a black armband (one of at least a dozen Dungeon Monitors). He told us we could not wander freely unless we had secured a play space. More rules and less play. This was a bad sign.

Despite state-of-the-art equipment and precise reenactments of common fetish and S/M pastimes, the atmosphere was stagnant and hackneyed. The most enthusiastic participant was the builder of the apparatuses; he explained the ingenuity of his hanging cages and swing sets with the delight of a carpenter on *This Old House.*

Valley parties aren't so different from a trip to Disneyland or Six Flags. Highly-stylized S/M is just another variation on the theme park or party, a form of entertainment that can be organized and paid for. Middle America may not think so yet, but to those who were into early S/M, the direction S/M has taken is significant, and disappointing.

—Marcy Sheiner

esters. Haute couture was never so sexy as the Moral Minority's ready-to-wear line, making latex fashion accessible to all of us. Custom-made outfits are also available and promise to fit "more snugly than a rock star's pants." They promise that your custom-made gear will remain unique, so don't worry about showing up in the same latex Little Red Riding Hood dress that everyone else is wearing.

—CB

Stormy Leather

Forbid yourself nothing...

1158 Howard St. (between Seventh St. and Eighth St.), San Francisco; (415) 626-1672; www.stormyleather.com. Open Daily: noon–7 p.m.

The atmosphere in this SOMA fetish shop is more hip boutique than smut shop, and the knowledgeable staff is always ready and willing to assist you in all their pink-haired, pierced glory. Stormy's claim to fame has long been women's leather fetish wear (made in Stormy's adjacent workshop), although they carry an excellent selection of toys and menswear as well. Browse the back wall for high quality floggers, paddles, sensory stimulators, and leather bondage gear and strap-on harnesses from Stormy's own label. A small but well-stocked book section carries great kink-oriented titles as well as fetish magazines from around the globe, and the store plays gallery to a regularly rotating showcase of high-end fetish art and photography. Make sure to check out the Stormy XL line which features high-quality leather clothing for plus-size women and crossdressers. Stormy also offers bridal registration for kinky brides-to-be who'd rather have a leather bustier than a blender.

—Mistress Morgana

"You know of course that the **Tasmanians**, who never committed adultery, are now **extinct.**"

— W . SOMERSET MAUGHAM

Fetish | SMBD

A Taste of Leather

Tastes so good...

1285 Folsom St. (at Ninth St.), San Francisco; (415) 252-9166;
www.tasteofleather.com. Open Daily: noon–8 p.m.

Established in 1967 as a store specializing in "sexually oriented goods for
the liberated consumer," this leather shop caters to a mostly gay male
clientele, although they welcome all stripes. They feature an impressive
selection of toys designed to test your ass and cock. Men looking for that
perfect Folsom Street Fair ensemble (and the toys to use later that night)
will be delighted by the store's selection of leather harnesses, bondage
gear, codpieces, rubber and silicone dildos and anal beads, safer sex sup-
plies, and cock restraint devices in leather, steel, and acrylic. The store is
small and packed with all manners of pervy delights, and an overhead
television plays nonstop leather porn to inspire your shopping.

—Mistress Morgana

Also at 2370 Market St. (at Castro St.), San Francisco; (415) 552-4500.

"Remember, if you smoke after sex,
you're doing it too fast." – ANONYMOUS

Bondage-A-Go-Go

Chips, dip, chains, and whips.

At the Cat Club: 1190 Folsom St. (at Eighth St.), San Francisco; (415)
431-3332; www.bondage-a-go-go.com. OpenWednesdays: 9:30 p.m.–
3 a.m.; $5 cover before 11 p.m., $7 afterward.

The cover is cheaper before 11, but the craziness doesn't kick into full
gear until around 1 a.m. At that point most of the crowd has gone home
and you're left with the hardcore fetishists. If you're new to the scene, the
veterans will welcome you as long as you are dressed appropriately and
don't act like an ass. There are bondage demonstrations, two dance
floors, two bars, and lots of people into BDSM.

—Alan Home

Play Time!
At the Power Exchange

The Power Exchange reigns as San Francisco's only public, BDSM-oriented sex club. An exclusively gay men's club (the **Substation**) occupies two upper floors, and all other persuasions find play space on the labyrinthine two lower floors (the **Mainstation**).

I've frolicked amongst the Mainstation's various fantasy playrooms, dungeons, continuous porn screenings, and dance floor (complete with stage and poles for aspiring strippers) for the past several years. The scene heats up around midnight and generally cools down around 3 a.m.

Upon entrance, you can trade your clothes for a club-provided towel. Do what's most comfortable; I've seen people wearing street clothes, all types of fetish clothing, towels, and nothing at all.

On the first floor is a lounge area that opens onto the dance floor, a juice bar, a small sex store, and play space, which includes a sling, semi-private cubbies with beds, and "jail" cells containing various S/M paraphernalia. Downstairs, the main dungeons sport a wider array of S/M equipment, more fantasy-themed cubbies, the porn video lounge, and most of the action. Spectators are welcome and often outnumber the players. A good S/M scene or hot sexual encounter will quickly draw a flock of onlookers, some of whom masturbate contentedly.

Single men are welcome, and on several of the nights I've been there, they have significantly outnumbered the women. Club monitors roam the floors, making sure boundaries are respected and safe sex supplies remain plentiful and utilized. Lube, condoms, Saran Wrap, gloves, rubbing alcohol, and water are available throughout the club, but no drugs or alcohol are permitted.

The Power Exchange holds three special events each month. The first Wednesday is ladies-only Wet Wednesday. The third Saturday, the Exchange Ball and Slave Auction is held. This is recommended for first-time visitors wanting to get their feet (and possibly more) wet. The fourth Friday is Couples Night for male-female or female-female couples (no transgendered or single men).

—Kathy Sisson

74 Otis St. (at Van Ness Ave.), San Francisco; (415) 487-9944; www.powerexchange.com. Open Thurs and Sun: 9 p.m.–4 a.m., Fri/Sat: 9 p.m.–6 p.m.

Fetish | SMBD

Rules of the Dungeon
Don't Offend the Hardcore Perverts!

Welcome to Sodom, Dorothy! You're not in Kansas anymore. This is your chance to go to a kinky club, a S/M dungeon, or a fetish fête. Contrary to popular fantasy, it's a world with a strict code of conduct. Screw it up and not only will you not get to screw, but you'll get bounced out of the club. Follow these rules to get in the door and maximize your cruising potential.

• **Dress the part:** You don't have to drop a fortune on new duds, but the more you adhere to the dress code, the more likely you'll be greeted as part of fellow freakdom. At fetish nightclubs you can wear outrageous clothes if you cover the privates. At a dungeon where it's mainly about S/M play, you can usually let it all hang out. When in Rome...

• **Don't touch:** Yes, that bare-bottomed babe hanging from the ceiling looks like a ripe piece of fruit ready for the picking. Don't touch. She's not your date or your slave. She didn't agree to play with you, she's only consented to being voyeured by others. Uninvited touch is the fastest way to be bounced out of the club.

• **Confess your inexperience:** Veteran kinksters love to show enthusiastic, polite newcomers around. You'll get lots of insider information such as where the private parties are. If you don't know how a local event or group does things, ask the organizers for their advice. They want you to have a good time too!

• **Keep your voice down:** It's distracting and rude to talk in a dungeon or play space. Don't make negative comments about other people's scenes regardless of how scary or creepy it may be to you. You think an enema's gross? You're scared of a double penetration suspension scene? You may be doing it a few months from now. It's often said that in the S/M scene, the phrase "I'll never..." translates to six weeks—at the most!

A good place cut your teeth on the pervy fetish nightclub environment is **Bondage-A-Go-Go** (see p. 92), as it's kinky without being a sex club or a dungeon. **The Power Exchange** (see p. 89) is also good for beginners of any gender, orientation, and perv factor. Make your own party for two or two dozen when you rent **Castlebar** (see p. 99), a dungeon space with lots of equipment. If you're not sure if BDSM is for you, try **Quality S/M** (see p. 96). It's the best place to buy kinky books and sign up for excellent classes to get you on to the right path.

Fetish | SMBD

Organizations for meeting like-minded pervs:

Society of Janus: Pansexual and heterosexual education/support organization devoted to the art of safe, consensual, and non-exploitative power exchange. Twice-monthly meetings feature a variety of BDSM topics. www.soj.org.

The Exiles: Social and educational organization for women with a positive personal interest in S/M between women. They have monthly educational programs, a monthly newsletter, and hold social events. www.theexiles.org

The 15 Association: The oldest continuous gay male S/M club in western U.S., it's a social and sexual fraternity for gay men over 21 years of age and with all levels of experience into S/M. They have monthly play parties and annual club run in the country called "Boot Camp."www.the15association.org

—Midori

Jezebel's Joint

A bar for Doms and daddies, strippers and trannies.

510 Larkin St. (at Turk St.), San Francisco; (415) 345-9832.
Open Tues–Sun 6 p.m.–2 a.m.

With two floors, a pool table, a library, cheap drinks, and a decidedly dark 'n' sexy vibe, Jezebel's Joint is the meeting spot for dreadlocked, tattooed San Francisco fetish scenesters. Owned in part by the fine folks who run the Power Exchange, Jezebel's Joint is constantly reinventing itself. Every night at 8 p.m. the bar offers free movies sponsored by the San Francisco IndieFest, and the club now has some solid DJ nights like Friday's "Fiendish" and Saturday's "Asylum" with DJs from "Fake" and "Death Rock Booty Call" holding down the turntables. A great spot to take a date any night of the week as the club is large, yet somehow never crowded. There is always a private nook somewhere in the club for those "special" moments between two lovers hoping to inflict some painful pleasure on each other.

—CA

"Is it not strange that **desire** should so many years outlive **performance?**"

— SHAKESPEARE

Quality S/M (QSM)

Get your learn—and your rope-burn—on!

Call for address; (415) 550-7776; www.qualitysm.com. Classes start at $10.

Kind of like a Tupperware party for kinksters, QSM teaches classes on everything from basic knot tying to advanced Japanese rope bondage. Women, men, and couples who are interested in BDSM can find classes, readings, lectures, and seminars in their catalog of offerings. QSM is one of the most highly respected schools on S/M. Their wide selection of classes and demonstrations features titles such as "Vaginal Fisting: Learn to Do it Right" and "Bondage on the Fly," taught by world-renowned bondage expert Fetish Diva Midori.

—CB

Slick Fetish Ball

If only your prom was this fun.

Held quarterly; location varies; www.clubslick.com. $20 in advance, $25 at the door.

San Francisco kinksters looking to flaunt their fetish seek out Slick, the city's longest-running Fetish Ball. First held at Gay Pride in 1995, this pansexual club can draw crowds of up to 750 people, and offers a fun and fiercely fashionable venue for those with a penchant for public display. The production team has changed over the years, as has the frequency of the event and its location, but Slick has maintained its reputation for high-fetish glamour (enforced by a strict dress code) and eye-popping performances and art by such S/M glitterati as Fetish Diva Midori, Michael Manning, Dark Garden, Stormy Leather (a frequent sponsor), and more.

—Mistress Morgana

"I chased a girl for **two years** only to discover that her tastes were exactly **like mine:** We were both crazy about **girls.**"

— G R O U C H O M A R X

Change your Tune
The Beauty of Porn-E-Okie

There are precious few things that drunken hipsters love more than karaoke and porn. San Francisco bar owner Chicken John took note and created "Porn-E-Okie." At a recent Porn-E-Okie party in an underground San Francisco art space, drunken dudes, lusty lesbians, and a few Filipino trannies sang along to such classics as Madonna's "Like A Virgin" and Whitney Houston's "I Will Always Love You" over some of the filthiest 1980s XXX action ever seen.

The juxtaposition of heartfelt lyrics over staggeringly dated porn flicks proved highly entertaining for the packed house, especially the serendipitous moments when the lyrics blended seamlessly with the porn, eliciting howls of laughter from the crowd.

John claims he never edits the scenes, which often match their respective song. He simply puts in an old XXX tape, starts the karaoke machine, and runs the two together via a video splitter. "When the video matches the song lyrics, it's brilliant and hysterical and I feel like an artist," says John.

But not just any aspiring Porn-E-Okie MC with a karaoke machine and a VCR can plug in porn and call it Porn-E-Okie. "You need to be a bit of a tech type," claims John. "There are problems that you have to fix on the fly, so in that way, I'm a porn technician."

Although John has done Porn-E-Okie numerous times in San Francisco and a few times in Brooklyn, he has bigger plans. "I'm gonna build a web site so that people can stream it and do it in their own homes or at parties," says John. "Everyone loves it!"

Well, not everyone actually. A few people felt compelled to leave during a particularly nasty defecation scene. The song playing at the time? George Michael's "Careless Whisper." Did they leave because the crap on screen offended them? Or was it the crappy music? Ah yes, it seems the mysteries of Porn-E-Okie are never-ending.

—Charlie Amter

Look for Porn-E-Okie listings and information at www.dammit.org.

Pimping Ain't Easy
San Francisco's Legendary Fillmore Slim Sings the Blues

Cruising through the Tenderloin in a Cadillac, Fillmore Slim asks his friend, Bobbie Webb, to slow the car to a glacial pace. As he rolls down his window, he yells, "Hey girl, it's Fillmore Slim from the movie *American Pimp*," he yells to a streetwalking beauty, who looks up and cracks a smile. "Come on over and talk to me, and we'll see if we can get you in *American Pimp 2*."

Although Slim ultimately fails to pique the interest of this particular professional, he is not worried. His pimping days are behind him. Now, Slim (a.k.a. Clarence Sims) is more interested in his blues career. At the age of 66, the guitarist recently played several blues festivals and released his first record in over 10 years—all in the wake of his scene-stealing turn in the 1999 documentary *American Pimp*.

Born and raised in New Orleans, Slim learned about the blues first-hand. "I done lived the blues," says Slim in a fast yet blurry drawl. "The blues is about picking cotton, working in the fields, living on the streets, and I did all these things."

Slim began playing in San Francisco's Fillmore District clubs like the Trees Pool Hall in the 1950s, quickly scoring gigs opening for B.B. King and Dinah Washington. "My sister warned me not to go down to Fillmore Street at that time," says Slim. "But everything was happening on Fillmore Street, so I had to."

By 1959, Fillmore Street was definitely happening for Slim. Both his pimping and his playing were in high demand. His first single, "You've Got the Nerve of a Brass Monkey," sold fairly well and received some national radio airplay; its success led to further releases. But even with a blizzard of 45s coming out, Slim was perennially broke. "I was so happy in those days just to have a record out that I forgot all about getting paid,"says Slim. "They had me stuck on the fame and the girls."

But Slim knew another way to get the Cadillac he so desperately wanted. Throughout the '60s and early '70s he cashed in on the sexual revolution by pimping out a stable of girls (as he recounts in *American Pimp*), making enough money to live comfortably.

Bt he was in and out of jail throughout the 1980s. He used the time productively, improving his chops.

Does Slim long for his former pastime? "I still do miss the game some-times," he says. "But I'm also glad I'm still here to talk about it."

—Charlie Amter

Castlebar

Kink every way you want it.

Discreet location in Bernal Heights; (415) 970-9700; www.castlebar.com. Open by appointment only: Sun, Tues–Fri: noon–11 p.m., Sat: noon–5 p.m.

You wouldn't expect to find a dungeon in San Francisco's quiet Bernal Heights neighborhood—and Castlebar is so covertly tucked away, that if you aren't looking, you won't find it. Dominants, submissives, and switches are available for private sessions for half or a full hour; BDSM, fantasy, fetish, wrestling, and crossdressing sessions are all offered. If you're looking for something more extreme you'll have to go else-where—no extreme play allowed. You have to contact your Domme or sub directly (you can check them out on the web site), and there is no charge for the pre-session interview. Castlebar is also be rented out to couples and small parties who want to play. Two rooms are offered: the Slave's Quarters and the Red Room—complete with toys and gear.

—CB

Fantasy Makers

Your every wish comes true.

Discreet location in El Cerritos; (510) 234-7887; www.fantasymakers.com. Open by appointment only: Mon–Sat: 10 a.m.–8 p.m.

One of the few dungeon play spaces left in the East Bay, this hotspot has been here since the beginning of time (or something like that). At least a dozen women provide BDSM, spanking, role-playing, wrestling, crossdressing, and more in a variety of rooms. If you can't get to San Francisco, but you desperately need to be punished and manhandled, then this might be the place for you.

—Jan Holder

Fetish | SMBD

The Gates

Abandon all hope ye who enter here.

Discreet location in Emeryville; (510) 261-RAGE (7243); www.thgatessm.com. Open by appointment only: Daily: 10 a.m.– 10 p.m.

If you're in the East Bay and need a fully operating dungeon with lots of girls to choose from, head for The Gates. With a bevy of enticing rooms to choose from, including the Formal Dungeon, the Bondage Room, the Boudoir, and the Medical Room, there is something to fit everyone's fetish bill. Located in a beautiful two-story Victorian house in Emeryville, the location is convenient if you are heading into or out of San Francisco—just right for that lunchtime bondage session.

—Jan Holder

Kitten With a Whip

Get frisky with this pussycat!

Discreet location in downtown San Francisco; (415) 26-KITTY (4889); www.kittenwithawhip.com. Open Mon–Fri: noon–7 p.m.

Natasha Strange is a dominatrix. You are nothing. She has a kick-ass web site. You are still on AOL. Despite all of the differences between you and the lovely, redheaded Ms. Strange, she will still take you on as a client— for a small fee. Once inside her private dungeon you can expect (according to her web site) a woman you'd never be able to meet in real life— and she'll leave you with nightmares! We'd like to thank this sadistic vixen for making San Francisco a better place for all of us to live.

—CA

"Sex: The thing that takes up the least amount of time and causes the most amount of trouble."

— J O H N B A R R Y M O R E

Mistress Simone

Discipline for the worst by the best.

Discreet location in Oakland; (510) 645-1047;
www.diabolicaldomme.com. Open Tues–Sat: 1 p.m.–8 p.m.
by appointment only.

It seems like there are less formal dungeons lately because so many girls
and pro-Dommes are creating private play spaces of their own. These
often have the same equipment, and usually a bit more love and indi-
viduality. If this sounds good to you, go directly to one of the best.
Mistress Simone Kross is one of San Francisco and Oakland's favorite
pro-Dommes. Her space in the East Bay is fully-equipped, discreet, and
convenient—and she's one of the most widely photographed fetish
models in the Bay Area. When you see her, you'll know why.

—CB

The Vinyl Queen

All hail the queen.

Discreet location; (510) 843-2207; www.vinylqueen.com.
Open Mon–Sat: 4 p.m.–10 p.m. by appointment only.

Continuing the trend of Mistresses and Dominatrixes leaving the dun-
geon fold, the Vinyl Queen has her own fantastic, private dungeon space
with three separate rooms in San Francisco. Once there, expect BDSM
adventures in body worship, corporal punishment, nipple torture, fem-
inization, and our personal favorite, e-mail training! The Vinyl Queen
does not engage in blood play or sexual activity. So don't even ask.

—CA

Still Horny?

If It Itches, Go See a Doctor!
Free Clinics

First things first: It is a good and natural thing for people to have sex and plenty of it. We are the last people to tell you not to enjoy yourself, but we do care about your health. So, please, for God's sake, use a condom…every time. In this day and age, sexual partners (like drug dealers) can't always be trusted to tell you what they really have. And, with the way health insurance companies are these days, some folks simply don't know. Didn't your mother always tell you that it's better to be safe than sorry? Free clinics and health care for all are just another way that San Francisco kicks ass. Sure, it's why we have one of the largest homeless populations, but wouldn't you rather everyone using those fancy pay toilets on Market Street be cootie-free? So, if you're smelling less than fresh, oozing out of any holes, bleeding when you're not supposed to, have crabs that aren't from the Pacific, or just want a few free condoms or the pill, here are some clinics that can help you out.

Berkeley Free Clinic: 2339 Durant Ave. (between Ellsworth St. and Dana St.), Berkeley; (510) 548-2570.

Haight Ashbury Free Medical Clinic: 558 Clayton St. (at Haight St.), San Francisco; (415) 487-5632; www.hafci.org.

New Generation Health Center: 625 Potrero Ave. (at 18th St.), San Francisco; (415) 502-8336.

Planned Parenthood Golden Gate: Civic Center, 815 Eddy St. #200 (between Franklin St. and Van Ness Ave.), San Francisco; (415) 441-5454; www.plannedparenthood.org.

San Francisco Community Clinic Consortium: 501 Second St. (at Bryant St.), San Francisco; (415) 243-3400.

San Francisco Free Clinic: 4900 California St. (at 11th St.), San Francisco; (415) 750-9894. www.sffc.org.

St. Anthony Free Medical Clinic: 105-107 Golden Gate Ave. (at Jones St.), San Francisco; (415) 241-8320; www.stanthonysf.org.

Tom Waddel Clinic: 50 Ivy St. (at Laguna St.), San Francisco; (415) 554-2950.

Women's Community Clinic: 2166 Hayes St. #104 (between Stanyan St. and Cole St.), San Francisco; (415) 379-7800; www.thewomensclinic.org.

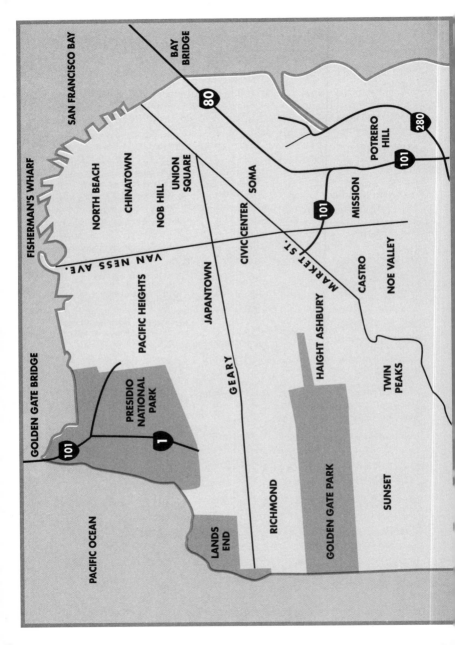

Alphabetical Index

A

Adult Media, 35
Alla Prima Fine Lingerie, 39
Art For Sex, 27

B

Backflip, 19
Baker Beach, 70
Barbaray Coast Adult Theatre, 4
Barry and Shell, 76
Big Al's, 26
Black Books, 50
Blowfish.com, 55
Blue Sky Massage, 78
Bluedoor.com, 55
Bondage A-Go-Go, 92
Bonny Doon, 70
Boys Toys, 6-7
Brass Rail, 20

C

Cake Gallery, 44
Candid Club, 20
Cantankerous Lollies, 5
Carol Doda's Campagne and
 Lace, 39
Castlebar, 99
Castro Street Fair, 71
Cat Club, 19
Centerfolds, 11
Chadwick's of London, 40

Chocolate Fantasies, 44
Cleis Press, 50
Condor Sports Bar, 9
Craigslist.com, 53
Crazy Horse, 11

D

Dal Jeets, 42
Dark Garden Unique Corsetry, 85
Darkplay.net, 63
Devil-Ettes, 5
Diva's Nightclub and Bar, 6
Don's of Sixth Street, 35

E

East Bay Voice, 86
Empire Health Spa, 78
Endup, The, 19
Eros Guide, 58
Erotic Chocolate Shoppe, 44
Exiles, The, 95
Exotic Dancers Alliance, 54
Exotic Erotic Ball, 72

F

Fantasy Makers, 99
Fashion Exchange, 42
Felicity's Fetiche, 44-45
15 Association, The, 95
Fog City Pleasures, 60
Folsom Street Fair, 71
Foot Worship, 85

Foxy Lady Boutique, 45
Frenchy's Video, 26
Frontlyne Video, 28
Frugaljohn.com, 60
Fuckingmachines.com, 63

G

Gamelink.com, 57
Garden of Eden, 13
Gates, The, 100
Gold Club, The, 7
Golden Gate Video, 36
Good Vibrations, 27
Greenery Press, 50-51
Grey Whale Cove State Beach, 73

H

Hagmire Pond, 73
Hanky Panky, The, 20
Hip Hugger, The, 20
Hot Tubs on Van Ness, 80
House of Ecstasy, 28
Hungry i, 8

I

Image Leather, 87
International Professional
 Surrogates Association,38

J

Jezebel's Joint, 95

K

Kit Kat Club, 20
Kitten with a Whip, 100

L

L.A. Gals, 13-14
Lands End Beach, 74
Larry Flynt's Hustler Club, 8
LastGasp.com, 51
Le Video, 30
Leather Etc., 87-88
Leather Masters, 88
Les Cent Culottes, 40
Little Darlings, 14
Lovings.com, 61
Lusciouswear, 45
Lush, 76
Lusty Lady, The, 17

M

Magazine, The, 30-31
Market Street Cinema, 19
Mr. S Leather and Fetters, 84
Mistress Simone, 101
Mitchell Brothers O'Farrell
 Theatre, 21
Moral Minority, 88-90
My Boudoir, 40-41

N

Naughty Cakes, 44
New Century, The, 22
New York Apparel, 46
Nikki's Oriental Massage, 80
Nob Hill Mini Lingerie Theater, 4
North Beach Movies, 31

O

On Our Backs, 51
Ouchytheclown.com, 64

P

Palm Tree Massage, 81
Panther Beach, 75
Piedmont Boutique, 46
Pink Poodle, 20
PleasureZone 69, 76
Pomponio State Beach, 75
Porn-E-Okie, 97
Power Exchange, 8
Punany Poets, 86

Q

Quality S/M, 96

R

Red Rock Beach, 77
Roaring 20s, 22
Romantasy Exquisite Corsetry, 41
Rubbish, 76
Ruby Skye, 19

S

San Francisco Dollhouse Cinema, 36
San Francisco Pride Parade, 71
San Francisco Sex Information, 54
Sex.com, 57
Sexy and Foxy, 61
SF Goth.com, 64
SFredbook.com, 52
SFSirens.com, 65
Slick Fetish Ball, 96

Society of Janus, 95
Spectator Magazine, 52
Stitch Bitch, 65
Stormy Leather, 91
Sugarpuss, 47
Sun Spa, 81

T

Taste of Leather, A, 92
Top Video, 32
Toujours, 41
T's Caberet, 20
Two Knotty Boys, 66

U

Up Your Alley, 71

V

Video Tokyo, 32
Vinyl Queen, The, 101
Vixen Creations, 29

W

Wild J's, 38

X

Xanadu Video, 86
Xandria.com, 58

About the Contributors

Amanda X is a former exotic dancer who now searches for better ways to utilize her Philosophy degree.

Rebecca Anderson writes many sex and children's books—usually under different names.

Chevara Angeles is a freelance writer for bluedoor.com who was born and raised in the city of San Francisco. He can be contacted at chevara_angeles@hotmail.com.

As a virgin to the turgid insistence of sharing her moist writing to the prying eyes of the public, **Rachel Blado** is a proud first-time contributor to this book. She enjoys exposing her thoughts and impressions as much as her panties to the world, and hopes to unleash her erotic fiction shortly.

Jack Boulware is the author of two books, *Sex American Style* (St. Martin's) and *San Francisco Bizarro* (Feral House). He has also written for *Salon*, *Wired*, *Arena*, the *Independent*, *Playboy*, *New York Times Magazine* and the *Washington Post*.

Janelle Brown is a senior writer for Salon.com and has written for the *New York Times*, *Ms.*, *Spin*, and many other publications.

Dara Lynne Dahl is the owner/editor-in-chief of *Spectator* magazine. She is also really, really horny most everyday!

Dancer X has decided to remain anonymous because her contributions are the truth, and she has discovered that the truth angers people. She has a Master's degree in writing and usually enjoys stripping immensely.

Diamond Dave is strip club DJ extraordinaire. He lives in San Francisco.

Dick Deluxe is an San Francisco-based musician, Internet entrepreneur, comic strip author, and strip club aficionado. In addition to his erratic appearances in dives as a punk/blues vocalist/guitarist, Mr. Deluxe is starring in the noveau opera *The God Machine* scheduled for New York's Lincoln Center in the fall of 2003.

Mike Ferro writes about all things that start with the letter "s"—including sex and San Francisco.

Jon Alain Guzik is a writer and journalist living in the wilds of Los Angeles. He was the co-editor of 2002's *Horny? Los Angeles*, which was on the *Los Angeles Times* bestseller list for almost three months. He loves you all. Truly.

Gary Hanauer is a well-known San Francisco Bay Area-based publicist

and freelance writer. This is the tenth book to which he's contributed.

Jan Holder has had sex with more people than you could ever imagine.

Alan Home is a horny, angry man from the San Francisco Bay Area. He is currently trying to turn his web site www.ugtv.org into a television show.

Dan Hullman loves to streak across Market Street at twilight. He is trying to get into the *Guinness Book of World Records* for "most times arrested naked."

Jessica Hundley has written for the *Los Angeles Times, Hustler, Flaunt, Maxim,* and countless other publications. She is also the co-editor of *Horny? Los Angeles.*

Dan Kapelovitz is currently the Features Editor of *Hustler Magazine.* When he's not interviewing feces eaters, auto-fellators, and dolphin f**kers, Kapelovitz produces the mind-expanding television show *The Three Geniuses* and acts as the figurehead for the psychedelic sex cult The Partridge Family Temple.

Nick LeBon is an international man of mystery who splits his time between his rustic chateau in the South of France and his basement efficiency apartment in Brooklyn.

Carol Leigh (a.k.a. Scarlot Harlot) has been working as a prostitute, activist, and artist in the Bay Area for the past 20 years. As a founding member of ACT UP (in San Francisco), she organized a campaign against mandatory HIV testing of prostitutes. She has appeared on ABC's *Nightline* and was recently seated on the San Francisco Board of Supervisor's Task Force on Prostitution representing San Francisco's Commission on the Status of Women.

Kelly Lewis' erotica and sex writing has been published in www.venusorvixen.com, *Dark Sex, Sex: Sausage is a Food,* and the British sex parody magazine *By George, There's a Queen in my Pocket.*

Anne N. Marino is the author of the novel *The Collapsible World* (W.W. Norton & Co.). Her work has appeared in the *San Francisco Chronicle* and the *San Francisco Chronicle Sunday Magazine,* as well as other publications.

Although she now has to don the corporate duds as a senior producer for Frog Design, **Margot Merrill** still has some really sexy things in her closet—really!

Fetish Diva **Midori** travels the world speaking on and teaching workshops on adventurous sex to help couples improve their communication skills towards deeper intimacy. Raised in a feminist intellectual Tokyo household, she holds a degree in psychology from UC Berkeley.

She has appeared on and written for HBO, BBC, *Mademoiselle*, *Playboy*, *Der Spiegel*, *Wired*, *British Esquire*, *British Vogue*, and many more. Learn more about her at www.FHP-inc.com.

Lisa Montanarelli is the co-author of *The First Year—Hepatitis C* (Marlowe & Co). She has been published in *Best Fetish Erotica*, the *San Francisco Bay Guardian*, *Agence France Press* (AFP), and other magazines and web sites.

Mistress Morgana is a San Francisco-based pro-Dominatrix and sex education instructor. She has written for the *San Francisco Bay Guardian*, *Eros-guide*, and more.

Michelle Parsons is a San Francisco-based freelance writer.

Dave Patrick has made his living writing about and photographing sexy people since 1973. He's currently Senior Editor and Chief Photographer at *Spectator*, but his work has also appeared in *Playboy*, *Penthouse*, *Hustler*, and *Rolling Stone*.

Anthony Petkovich is the managing editor of *Spectator* magazine. He also contributes to *Headpress* (U.K.), *Psychotronic Video Magazine*, *Genesis*, and is the author of *The X Factory*.

When she's not giving "service with a smile," **Genevieve Robertson** spends her time making her fledgling publication *Shades of Contradiction* all that it can be.

Steve Robles has written for GettingIt.com and the *San Francisco Bay Guardian*, as well as lots and lots of really nasty porn sites.

Thomas S. Roche is the author, editor, or co-editor of 12 published books, including the *Noirotica* series of crime-noir erotica. He has lived in the Mission since 1996.

Marcy Sheiner is editor of the *Herotica* series and of *Oy of Sex: Jewish Women Write Erotica*. She has written for *Playboy*, *Penthouse*, the *San Francisco Bay Guardian*, and many other publications.

Kathy Sisson is a sex researcher and writer trying to maintain her academic credibility while living a life of debauchery and hedonism. Fortunately, she has a day job as a private chef.

David Steinberg writes frequently about the culture and politics of sex (available free and confidential from him at eronat@aol.com). His second biggest passion these days is photographing real couples being genuinely sexual in their own homes.

Dave Williams is a writer who has lived in San Francisco his entire life.

About the Editors

Cara Bruce is the editor of *Best Fetish Erotica, Best Bisexual Women's Erotica,* and *Viscera.* She owns and runs Venus or Vixen Press (publisher of *Viscera* and *Embraces: Dark Erotica*) and www.VenusOrVixen.com. She is the co-author of *The First Year—Hepatitis C* with Lisa Montanarelli. Her short stories have appeared in numerous anthologies including *Best American Erotica 2001, Best Women's Erotica 2000-2004, Best Lesbian Erotica 2000, Mammoth Book Best of the Year Erotica 1 & 2, Uniform Sex, Starf*ckers, The Unmade Bed, The Oy of Sex, Best S/M Erotica, Best Bondage Erotica,* and *Pills, Chills, Thrills and Heartache,* to name a few. Her writing has been published in many web sites, magazines, and newspapers, including Salon.com, *San Francisco Bay Guardian, While You Were Sleeping, On Our Backs,* GettingIt.com, and many more. She lives in San Francisco. Check her web site for more information: www.venusorvixen.com.

Charlie Amter's writing has appeared in *Hustler, FHM, San Francisco Magazine, Wired, Maxim,* Nerve.com, *Contents,* MTVnews.com, *City* magazine, the *SF Weekly,* BayInsider.com, the *East Bay Express,* the *Miami New Times, Minneapolis City Pages,* the *San Francisco Bay Guardian,* the *San Francisco Examiner* and more. He is also a contributing writer to Avalon Publishing's first edition of *Moon Metro: San Francisco.* He continues to live in San Francisco's Tenderloin district, although he is not really sure why.

Petra, our stern taskmistress, demands you tell her:

Where do you go when you're horny?
Did we miss your favorite place?
Willing to bare your sinful secrets to our prying eyes?

Email us at
Horny@reallygreatbooks.com
There's no guarantee we'll use your idea, but
if it sounds right for us we'll let you know.

DON'T GET HORNY WITHOUT US!

"Out-of-towners can read it and weep."
— PLAYBOY

☐ **Horny? Los Angeles**

1-893329-16-X

$18.95

☐ **Horny? New Orleans**

1-893329-47-X

$18.95

☐ **Horny? Miami**

1-893329-78-X

$18.95

☐ **Horny? Las Vegas**

1-893329-33-X

$18.95

☐ **Gay & Horny? Los Angeles**

1-893329-33-X

$19.95

☐ **Gay & Horny? San Francisco**

1-893329-50-X

$19.95

Payable in U.S. Funds only. No cash accepted. Postage & handling: $2.oo for one book, $1.oo for each additional. Foreign and Canadian shipping prices higher (please e-mail Shipping@ReallyGreatBooks.com for actual amounts). Prices, postage and handling charges may change without notice.

ORDER AT www.ReallyGreatBooks.com

Or, list quantity of above books and send this order form to:

Really Great Books
P.O. Box 86121
Los Angeles, CA 90086
Please allow 4–6 weeks for delivery.

Foreign and Canadian
deliver 8–12 weeks.

Bill my: ____Visa ____ MasterCard

Card #_____ exp.____

Daytime Phone #_____

Signature_____

Or enclosed is my ___check ___money order

Ship to:

Name_____

Address_____

City_____

State/Zip _____

Book Total $_____

Applicable Sales Tax (CA) $_____

Postage & Handling $_____

Total Amount Due $_____

eros.com

The world's largest online adult entertainment guide.

US and International city guides to local entertainers, shopping, clubs, lifestyle info, news, reviews, event listings, erotica and our famous escort and domina guides.

Plus our hand picked favorite guide to the web's best adult sites, the world's best erotic artists and fetish photographers, insider information about exotic destinations, and our search engine to help you find anything we forgot.

NOTES

NOTES